IMAGES
of America
ITALIAN AMERICANS
OF GREATER ERIE

Best Regards,
Norma Palandro Webb

Best Wishes,
Sondra Lee

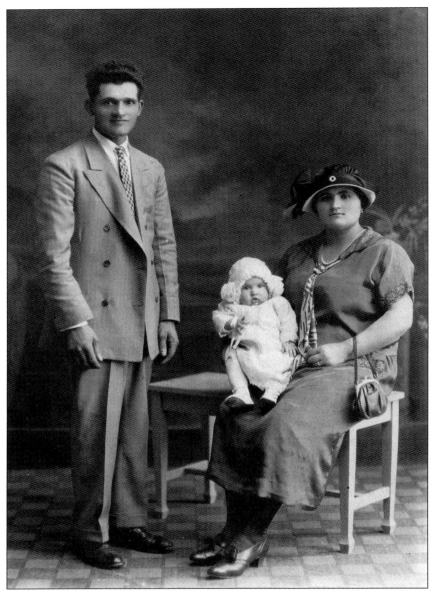

The family is the center of life in the Italian community. Resilience and strong values are taught. Felice and Francesca Sforza Palandro emigrated from Onano, Viterbo, in 1923. By 1929, the young mother had lost two baby boys to communicable diseases and was a widow. Left to raise her three-year-old daughter Norma, she became a seamstress. She later remarried and had two other girls, Elvira and Amalia Salvagnini. (Norma Palandro Webb.)

ON THE COVER: Pictured in this old 1910 outdoor photograph is the wedding reception of Phillip Savelli and Quintina Cellini, first row, second and third from left. In the second row, left, is Vincenzo Savelli, brother of the groom. In the third row, from left to right are Colombo Achille, Ernesto Mazza, Luigi Malizia, and unidentified. Others in the picture are also unidentified. Notice the bedspread on the clothes line for a backdrop. Italian immigrants were very resourceful. The Savellis emigrated from Sezze. (Victor Savelli.)

IMAGES *of America*

ITALIAN AMERICANS OF GREATER ERIE

Sandra S. Lee, Mary Lou Scottino,
and Norma Palandro Webb

Copyright © 2010 by Sandra S. Lee, Mary Lou Scottino, and Norma Palandro Webb
ISBN 978-0-7385-7262-8

Published by Arcadia Publishing
Charleston SC, Chicago IL, Portsmouth NH, San Francisco CA

Printed in the United States of America

Library of Congress Control Number: 2009936319

For all general information contact Arcadia Publishing at:
Telephone 843-853-2070
Fax 843-853-0044
E-mail sales@arcadiapublishing.com
For customer service and orders:
Toll-Free 1-888-313-2665

Visit us on the Internet at www.arcadiapublishing.com

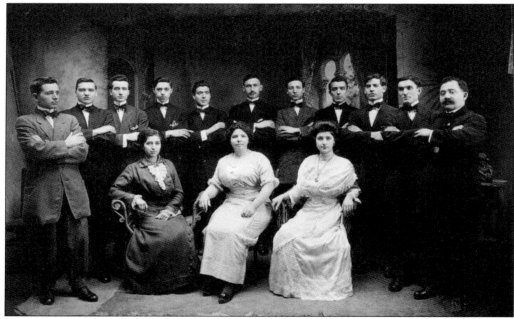

In the early 1900s, Italians had already begun to influence the social and cultural scene in Erie. Shown here is a local group of actors who staged a play at the Erie Maennerchor Club. Egidio Agresti is standing center. Seated in center is Angeline Scalzo Agresti, and women on either side not specifically identified are Lena Agresti and Mrs. Mango. (Egidio Agresti Archives.)

Contents

Acknowledgments		6
Introduction		7
1.	Family and Community	11
2.	Work and Professions	45
3.	Education, Youth, and Sports	73
4.	Military	85
5.	Church and Religion	99

Acknowledgments

We thank all those dedicated persons who pored over family albums, looked through dusty boxes stored in attics, and contacted other family members to find old photographs and historical information. We have done our best to be accurate, recognizing that spellings of family names and villages often changed over the years.

Charles Catania graciously provided history on Erie's Italian neighborhoods. Other individuals provided information or support to this project, including Patrick Cappabianca, Frank Arduini, Meg Loncharic, Liz Allen, Vicki Corapi, Gino Carlotti, and our ever helpful editor, Erin Vosgien. We acknowledge the Sisters of St. Joseph for their continued interest in the revitalization of Erie's Little Italy.

Information has been gathered from many articles that have appeared in the *Erie Times News* over the years. We consulted old church programs and booklets; *La Gazzetta di Erie*; and an excellent article by David L. Hood in *The Journal of Erie Studies* in 1993 entitled "Erie's Italian People: The Genesis and Development of Little Italy." We are privileged to have had access to the estates of Paul Morabito and Egidio Agresti.

We are especially grateful to our many ancestors, whose resilience, values, hard work, and faith are honored here.

Sandra Lee: I thank my parents, Robert and Irma Lee, who instilled a love of learning; Luis Barranon, husband and muse; and all of our family members who supported this project. I'm indebted to our Italian ancestors from Mercenasco, the Leas and the Demangones, because my research into our family history got me started on this path.

Mary Lou Scottino: A sincere acknowledgment to my late husband, Dr. Joseph Scottino, for inspiring and awakening within me an interest and love of Italian culture and heritage and gratitude to my children, Tom Scottino, Margaret Irvin, and Mary Anne Kundrat, for their support and encouragement in bringing this book to completion.

Norma Palandro Webb: I wish to thank my husband, Bill, for his love and support during this project and my children, Diane Will, Richard, and Robert Hammar, for their love and deep interest in their Italian heritage.

INTRODUCTION

Erie's first recorded Italian immigrant, Raffaele Bracaccini, arrived in 1864. He was a musician, a member of the band in a traveling carnival show that came to Erie. He took an afternoon off and rowed out into the bay to do some fishing. When he saw the beauty of the lake and surrounding countryside, he fell in love with it and decided to stay. Another Italian, Vitale Spadaccini, arrived three years after the end of the Civil War, in which he had served in the Union Army. He became a leader in the community, and later his son, Charles, became a power in Erie politics. In 1868, there were still only three Italian immigrants in Erie. By 1891, when St. Paul's Church was founded, there were several hundred Italians, and a community was thriving. Some of the early Erie Italians were Carl Rossie, C. Bracini, Joseph Leone, Jack Madonna, Albert Pisa, Louis Phillips, and John Lucarotti.

Another accomplished musician, Caesar Morelli, immigrated to Erie in 1899. He was a member of the band with Buffalo Bill's Wild West Show and was so well entertained that he decided to make Erie his home. He organized Morelli's Band. It was considered one of the best of its time. Morelli was the first Italian admitted to the Erie Philharmonic Orchestra and the first Italian to become a professor, teaching music at Mercyhurst College. Later Cianfoni's Concert Band came into existence and was also considered to be in a class by itself. When the band was formed in 1916, it was called the Italian Youth Band.

Italians impacted culture in Erie even in the early 1900s. In addition to the two concert bands, operettas and plays were performed at the Park Opera House. Famous personalities of the day, such as opera diva Luisa Tetrazzini, were invited to sing, and plays were performed. The Calabrese Club, founded around 1920, featured entertainers such as Rudy Vallee and Edie Gorme.

An Italian-language newspaper, *La Chitarra*, was founded in 1914 by Egidio Agresti. In 1919, *La Chitarra* became *La Gazzetta di Erie*. Egidio Agresti, born in Naples, came to America in 1896 at the age of nine. He spoke four languages, and he published *La Gazzetta di Erie* for more than 35 years.

Some of Erie's early Italian history is found in the pages of *La Gazzetta*. In 1917, the only Italian attorney from the community, Edward Petrillo, was named by the governor to the committee for state security during World War I. Also in 1917, Luigi Filippi became a notary public and the first postal worker from the Italian colony; Dr. Frank Trippe came to Erie to open a medical practice.

In the late 1800s, most Italians in Erie were engaged either in fruit selling or working for the railroad companies. The first exclusive grocery store in the community opened at Sixteenth and Walnut Streets in 1904. It was considered a risky and daring business venture at that time.

In 1891, St. Paul's Parish was established in a frame building, formerly a Presbyterian church, on the east side of Walnut Street. The first recorded baptism, in 1892, was Adelina Torello. In 1893, the first recorded marriage took place between Giovanni Masiello and Anna Palermo, while 1897 saw the first recorded confirmation of Angelina Lombardozzi. The yearly August procession for the Feast of the Assumption took place as early as 1915.

Later, after attending a christening, 18 men met in back of Thomas Rossi's fruit store at Sixteenth and Peach Streets and pledged $100 each to build a new St. Paul's Church. The new

church was built in part by stones discarded from the streets and curbs being built in Erie at that time. Much of the labor was provided by Italian immigrants—stone masons and workers from the neighborhood and from Donora and Charleroi, Pennsylvania.

Church members held fund-raising campaigns. By June 1923, $46,349.25 had been raised, according to *La Gazzetta di Erie*. Many people had contributed nickels, dimes, and quarters. Flocks of the faithful turned out for the laying of the cornerstone in 1929. The church was finally dedicated in 1935.

History records that Fr. Raffaele Agresti, uncle of Egidio Agresti, was pastor of the early church from 1896 to 1908. Fr. Louis A. Marino, born in Cerisano, in the province of Cosenza, Italy, was ordained in 1905 and became pastor of St. Paul's Church in 1908. Other churches attended by Italian immigrants in Erie were St. Patrick's, St. Andrew's, Holy Rosary, Italian Christian Assembly, and Holy Trinity Lutheran Church.

In 1922, Columbus Park was completed for the enjoyment of the Italian colony. Elvira Calabrese was appointed in 1921 to teach at Perry School at Twenty-ninth and Cascade Streets. There was a small group of Italian students there from a neighborhood then called "Elmwood Avenue."

The communities grew and became vibrant neighborhoods. Many clubs and societies were formed based on the village of origin in Italy. Some offered insurance benefits to dues-paying members, providing funds for funerals or medical expenses of family members. The oldest, La Nuova Aurora Society, was formed in 1907. The Sons of Italy Society of Victor Emanuel III was founded in 1918. Founding members were Eugene Jordano, Raffaele Annunziata, Domenico Giordano, Giuseppe Perrino, and Michele Letizia. As early as 1920, a women's group was formed to assist the youth of the Italian colony. In 1924, the United Professional and Businessmen's Association was formed for the betterment of Italian professionals. The first members were Drs. Frank Trippe and Samuel Scibetta; attorneys John Galbo, Jess Jiuliante, and Edward Petrillo; dentist J. Amenta; Frank St. George, Leonard Pasqualicchio, A. J. Scolio, Dr. F. Aquino, and Egidio Agresti. The Wolf's Club was formed in 1956 with founding members Charles Catania, Rudolph and Pio Santia, Dr. A. J. DiSantis, and Ralph Yamma. By 1938, there were 25 Italian lodges and societies, including the Giuseppe Mazzini Civic Association, the Cesare Batiste Club, and many others. Founding members of the newly incorporated Giuseppe Mazzini Civic Association were Angelo Susi, Victor Rotunda, Ron DiVecchio, John Orlando, Larry Fatica, Hector DiTullio, and Dan Savocchio.

In the neighborhoods, children played stickball on the streets, or they watched movies and serials at the American Theater or the Lyric Theater on West Eighteenth Street. Mothers used to come to the theaters and call their children's names to come home for dinner. Many Erie Italian Americans remember attending the movies or working as ushers and usherettes.

The Italian neighborhoods grew dramatically, and by 1911, there were 3,000 Italians in Erie. Nine years later, in 1920, there were 11,000 Italians, 80 percent of whom lived in the area of Sixteenth and Walnut Streets, Erie's "Little Italy." Numbers continued to increase, and by 1938, the 18,000 Italians in Erie comprised the third largest ethnic group.

Little Italy, the largest Italian neighborhood, extended from Thirteenth to Nineteenth Streets, from Myrtle to Cranberry Streets. Immigrants from Northern Italy lived in the neighborhood of East Twenty-sixth and Brandes Streets. Another enclave existed from Third to Fifth Streets, between Holland and Parade Streets. Finally, *paesani* from Pennapiedemonte clustered from Second to Fifth Streets, between Cranberry and Liberty Streets. The Penna Piedmonte (PENN) Club was located on West Fourth Street. The "Penni" or "Penniole" belonged to St. Andrew's parish. Other immigrants moved to farms in outlying areas such as Northeast, Fairview, and Wesleyville, Pennsylvania.

An article by Charles Catania in the *Erie Times News* on November 1, 1997, describes Erie's other Italian neighborhoods. On the lower east side, from Holland to Parade Streets and East Third to East Fifth Streets, lived many immigrants from Sicily, Calabria, and Abruzzi. St. Patrick's Church was the faith center of this community, while the Cesare Battista Club provided a gathering place for socializing and dancing to local bands.

Grocery stores on East Second and Holland Streets, East Fourth and German Streets, and East Second and German Streets were operated by the Manninos, the Abates, and the Leonettis. Other last names from this neighborhood were Messina, DeLuca, Alo, Siciliano, Amendola, Chimenti, Borgia, Naccarato, Destrini, Cassano, Spinelli, Patemitti, Porreco, Camera, Fillipo Chilelli, Intrieri, Calvano, DeSanto, Presta, Penna, Mando, DiDionisio, Bianchi, and DiBuono.

Some of the local business owners were Romolo Stefanelli, who made chocolate candies in his basement kitchen; Dominic DiNardo, who ran a grocery and ice delivery business; Vali, a shoemaker; DeSantis, who operated Sanders trucking; Fosco, a carpenter/contractor; and Sardini, DiSimone, DeCecco, and DeGeorge, who worked as general foremen on the docks, where many of the Penni worked to support their families.

On the Upper East Side, another neighborhood ran from East Twenty-fourth to East Twenty-eighth Streets and Pennsylvania Avenue to Elm Street, with a few families extending to East Avenue. Erie's six-term mayor, Lou Tullio, was a product of this neighborhood.

This neighborhood had three "hubs." One was A. Duchini, Inc., started by Avellino Duchini in a two-car garage on East Twenty-sixth Street. Many young sons of the immigrant families in the neighborhood worked there in the early years, and this group included many of Erie's future Italian American physicians who "piled block" and performed general labor to pay their college tuitions. This group included Joseph and Richard Cerami, Leo Verdecchia, John Trippe, Michael Santomenna, Larry Fatica, Richard Scibetta, and Bill Sandusky.

Another hub was Verdecchia's Grocery, on Twenty-seventh and Brandes Streets. As in many Italian businesses, the entire family worked in the store, and it was described as warm and welcoming.

The Liberty Club, on East Twenty-sixth Street, was the third hub of this neighborhood. Here English and naturalization classes were held and taught by Tom "Pop" Toskin, a welder by trade, who also served as coach of the various junior and senior athletic teams that represented the "Liberties." The Liberty Club was the place for political rallies, parties, and various receptions.

Other names from this neighborhood were Pieretti, Cichetti, Angelotti, Gianoni, Carnevale, Yezzi, Marchini, Narducci, DiNicola, Nicolia, DiSanti, Malatesta, Sansone, Bartone, Fiorito, Rotunda, Frazzini, Berarducci, Ferretti, Madonnia, Finazzo, and Catania.

Author Norma Webb reflects on life growing up in Erie's Little Italy,

> I was born in a third floor flat in a brick building that housed the American State Bank and the Philips Fruit and Produce Company located on the 400 block of West Sixteenth Street. Dr. Frank Trippe was the attending doctor at my birth. Dr. Samuel Sciabetta, who founded Rose Memorial Hospital, also served the needs of the Italian immigrants and their families at that time, along with Dr. Anthony Narducci, Dr. Michael Pistorio, and Dr. Charles Leone.
>
> Little Italy was a self-sufficient community. There were many family-owned grocery stores. The Majestic Bakery and International Bakery delivered bread to homes. La Gloria pastry shop was on the northeast corner of Sixteenth and Walnut. Michael Santomenna's pharmacy on West Eighteenth Street had a great soda fountain, and Henry's Ice Cream Parlor on the same block was also popular.
>
> There were two dry goods department stores—DeCecco's and Goldfarb's on West Eighteenth Street, as well as the "West Eighteen" Variety Store, and Flossie's, a ladies millinery store. There were several barber shops, and beauty shops for younger ladies. Many of the immigrant mothers wore their hair in topknots or twisted braids. My mother had her first hair cut and permanent wave in 1950, at the age of 52!
>
> Grocery shopping was a unique experience. Mothers sent children to the store for meat, pasta, and canned goods. Totals were marked in the book we carried, and in a ledger at the grocer's. I was 10 or 11 before I realized that the purchases were paid for at the end of the week when papa got paid. Money matters were not discussed in front of the children, but it was a point of honor to pay the bill.

John Philips was the president of the American State bank (Sixteenth Street), and Leonard Pasqualicchio was president of the Bank of Italy on West Eighteenth Street. Both banks failed in the 1930s. Many immigrants lost their savings, and others lost their homes. During the height of the Great Depression in the 1930s, the 'poor board' distributed food boxes once a week. I recall sitting on the porch steps waiting for the truck that dropped off "the box" for us. It contained slab bacon, canned meat, prunes, raisins, cornmeal, and a pouch of white lard and a yellow "pill" that you crushed into the lard and mixed until you had yellow margarine. We also got several loaves of sliced white bread. These things were novelties. Mom always cut our bread, and her slices were never "even," like the pre-sliced bread. Also the margarine was not a typical food on the Italian table.

Many families had a garden that provided fresh vegetables in the summer. In July, farmers from surrounding areas arrived with trucks loaded with tomatoes, peaches, pears, and other produce. Mothers would gather around and buy bushels of whatever was being sold to "put up" for the winter. Nothing was as satisfying to them as seeing row after row of jars of home-canned food to get their families through the winter months.

Hardly anyone had an electric refrigerator, so the icebox was used to keep food cold. Ice was purchased by the pound and amount needed was displayed on a card in the window of your home. The "ice man" would know how much was needed. He had a huge tong to sling the ice over his shoulder, protected by a rubber mat. It was hard work, as some pieces weighed up to 75 pounds! The ice was placed in a zinc compartment of the icebox and used to keep food cold. The melting ice drained through a tube into a pan under the icebox. Woe be to the child who forgot to empty the pan—it would leak all over the kitchen floor. In the winter, our icebox was a wooden crate nailed to the ledge on the outside of the kitchen window. Here we kept meat, milk, and eggs, and we did not have to buy ice.

In October, the air was filled with the aroma of grapes, which were delivered in crates from trucks. Crates were piled high on the sidewalk in front of the homes of families who would make wine in their basements using wine presses and large barrels for storing the wine. During Prohibition, each family was allowed so many barrels of wine for home consumption. However it was not unheard of for some families to have "back door" customers!

Columbus School was built in 1921 at Sixteenth and Poplar Streets. Most of the children of Italian immigrant families were educated there. The only parochial school was St. Michaels, a German Parish on Seventeenth Street. I could not speak a word of English when I started school. We had kind teachers (Miss Mary Porreco stands out in my mind). When I went to Roosevelt School for seventh grade, I met new non-Italian girls and boys; we became friends and thus expanded our horizons. Our parents, meanwhile, were studying to become American citizens, learning new ways, and finding their niche in this land of opportunity and encouraging their children to become educated and realize their dreams.

We all hope you enjoy the photographs illustrating Erie's Italian history and people. The images and captions offer a slice of life from that history, the 1880s to 1950s.

One

FAMILY AND COMMUNITY

In 1929, this passport was carried by Antonia Bonfa Codespoti and her children, Caterina and Agata, as they left Samo, Reggio Calabria, to be reunited with their father and husband, Michele Codespoti. Michele had served with the American Expeditionary Forces in France during World War I and received the Victory Medal. He became a railroad worker and died in 1934, leaving a young widow to support her family by taking in sewing. (Agnes Ruscitto.)

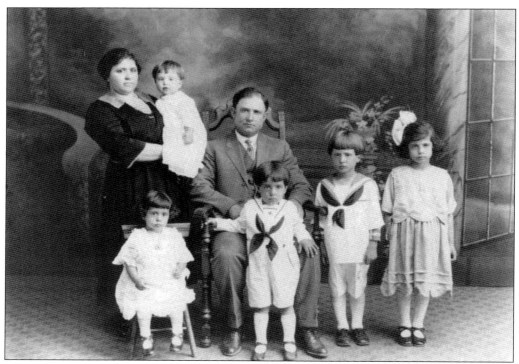

Michael Orlando, a stone mason, came from Montenero in 1900. His wife, Angelina Di Loreto, was from Alfedina, Italy. They are posing here with their family. From left to right are (first row) Evelyn, Quentin, John, and Fay; (second row) Angelina holding Robert and Michael. Quentin, an optometrist, became a city councilman and later a Pennsylvania state senator. John founded the John R. Orlando Funeral Home. (James Orlando.)

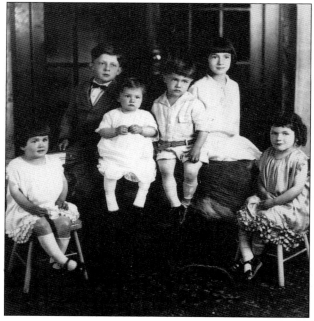

Pictured here are the Nathal (DiNatale) children in 1928. From left to right are Gloria, Victor, Dolores, Ralph, Venturina, and Coletta. Their parents, Giuseppe and Adelina (Giuliante), came to the United States from Palambaro, Chieti. Giuseppe worked in the coal mines of Pennsylvania, then settled in the lower west side colony of immigrants from Chieti. There were three other children born later: Alderico (Al), Delphina, and David. (Al Nathal.)

Annunziata Pallotto and her nine-year-old daughter, Adelgisa (Angeline), emigrated from Montenero in 1920 to join husband Antonio, who had arrived in 1913, boarding at 415 Huron Street. They traveled with an uncle, who was turned back at Ellis Island due to pink eye. Thus the young mother and child had to find their way to Erie on their own. Tragically Annunziata died in childbirth 18 years later (see below). (Nance Hoffman.)

Although funeral parlors were available, many Italian families preferred to have a wake or visitation for their loved ones in the home. Often a picture was taken as a memorial. In this picture is Annunziata Pallotto, wife of Anthony Pallotto. She died in childbirth at age 42 in 1930. Her baby boy also died and was buried in the casket beside his mother. (Nance Hoffman.)

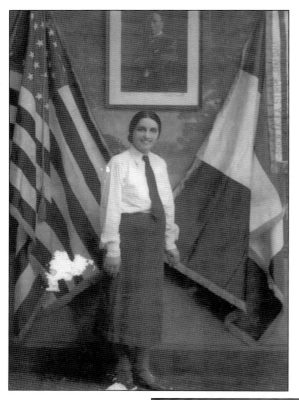

Luigina Barboni Cappabianca is shown in the office of her husband, Giovanni Cappabianca, the vice consul of Italy for Northwestern Pennsylvania. The Cappabiancas came to Erie from Porto Garibaldi, Italy, in 1926. The picture on the wall is of Benito Mussolini, who was premier of Italy in the 1930s. The vice consul's office did official work for Erie's Italian immigrants concerning properties and necessary legal business in Italy. (Lisa Cappabianca.)

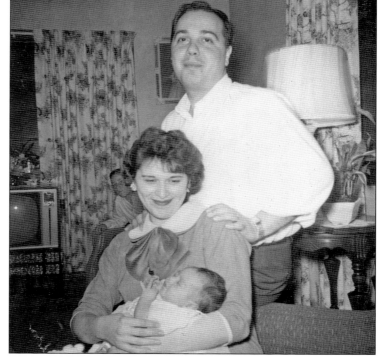

Patrick (Pasqualino) Cappabianca is pictured here with his wife, Placida (Patty), and daughter, Carla. Patrick was a school teacher and principal at Roosevelt School. He has an active political life as an Erie city councilman. Currently he is on a committee to restore sections of historic Little Italy. His daughters, Lisa and Carla, continue in the Cappabianca Travel Agency, and Maria and Linda are involved in school administration. (Patrick Cappabianca.)

Federico Troncone and his wife, Alessandra, emigrated from Marchenese in the early 1920s. Federico was a master baker. La Gloria Pasticceria was famous for *panettone* (Easter bread), *pane di spagna* (sponge cake), lemon gelato, and cannoli. His four sons all served during World War II. Troncone's family is pictured here, from left to right, in the early 1930s: (seated) Mario and Gladys; (standing) Pasquale, Alfonso, Concetta, Alessandra, Federico, and Generoso. (Gladys Grack.)

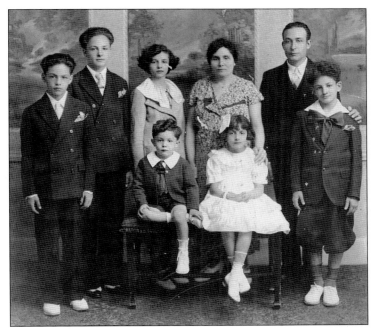

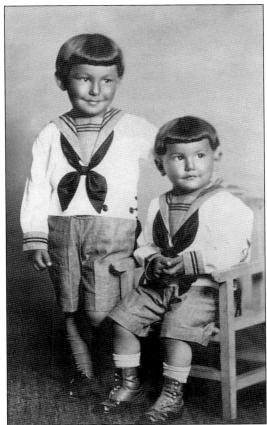

Shown here in their attractive sailor suits around the 1920s are two of the children of Brigida and Joseph Dascanio: Dan (Dominick), standing, and Babe (Bernard), seated. Brigida and Joseph Dascanio were emigrants from Pennapiedemonte. They lived first at 1129 West Fourth Street, later moving to the 900 block of West Fourth Street. Joseph worked on the railroad as a laborer, then worked at National Forge. (Patty McMahon.)

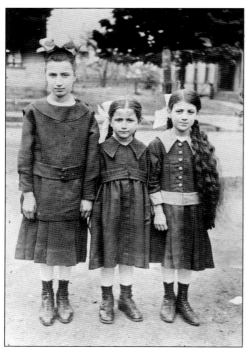

From left to right, Catherine, Nancy, and Victorine were the three oldest of eight children. Their parents, Antimo and Michelina Martino DeDionisio, came from Naples after marrying in Italy. Antimo immigrated in 1903 at age 16. In this c. 1915 photograph, they were probably living at 251 East Third Street. Another of their children, Andrew, is shown years later in the photograph below. (Diane DeDionisio Davies.)

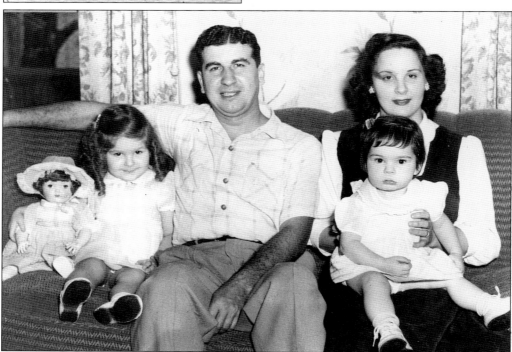

This photograph was taken around 1950 by a photographer who came to the DeDionisio home on Eighteenth and Sassafras Streets. Shown from left to right are Diane, Andrew, and Vera with Judy on her lap. Andrew was the child of Antimo and Michelina DeDionisio, who had immigrated in 1903. (Diane DeDionisio Davies.)

This is the John (Giovanni) Guido family in a portrait taken at Vagnarelli Studio on West Eighteenth Street. John married Maria Perri in their hometown of Amantea, Province Di Cosenza, Italy. He settled in Erie before World War I and then sent for Maria in 1921. It was an arranged marriage, and she was 10 years younger than John. The two children pictured are Antoinette (Ann) and Thomas. (Ann Guido.)

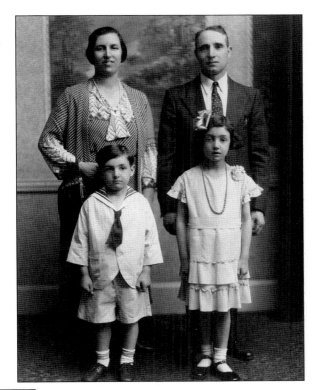

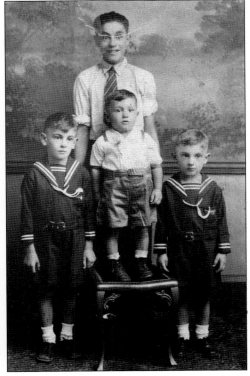

Pictured here are the sons of Emidio and Lucia Pallotto Minichelli. In the first row from left to right are Robert, Frank, and Richard. Egidio is standing behind. Egidio was born in Montenero, Italy, and immigrated to Erie with his parents in 1930 at the age of eight. Their home was at 951 West Seventeenth Street. (Robert Minichelli.)

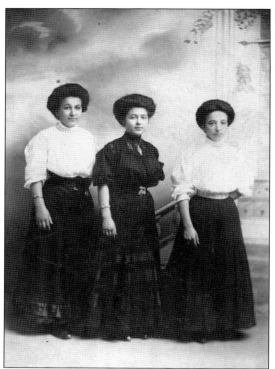

Close cousins Josephine Scolio Palmisano, Santa Bova Scolio, and Rose Buttice Palmisano pose in the latest fashion in 1904. Hair styles are bouffant and similarly worn by all three. (A. J. Scolio.)

Liborio and Santa Scolio emigrated from Sicily in the early 1900s. Shown here is one of their children, possibly Anthony. The Scolio family was well known in the city for the excellent selections of fruit and produce in their store. (Ann Scolio Carey.)

Pictured here in the early 1900s are four daughters of Carlo and Marianna Sansone Palmisano, emigrants from Termini, Sicily. Shown from left to right are Mary Restifo, Rose Buttice, Frances Pistory, and Josephine Scolio. Their father, Carlo, was in the fruit and produce business and established United Fruit and Produce Company, located on Eighteenth and Peach Streets. (Carol Restifo.)

Constantino and Rosina Angelotti emigrated from Pulica in the province of Masacarara, Italy. They are shown here with children Anita and Anthony in the second row. In the first row, from left to right, are children Henry, Joseph, Olivia, and Catherine. In the 1940s and 1950s, Henry had a restaurant on the corner of Seventeenth and Walnut Streets called Angelotti's Supper Club. It was well known throughout the city. (Lena Soccoccio.)

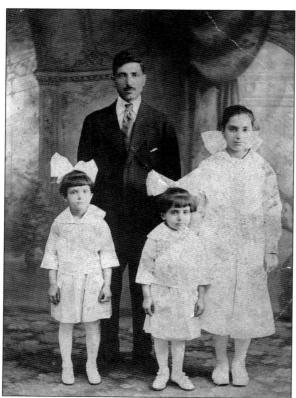

Frank Chiapazzi, a house painter, lived in Erie's Little Italy at Seventeenth and Cherry Streets with his family. He emigrated from Montalbano, Sicily. He is shown here with his three daughters, (from left to right) Frances, Angelina, and Lena. (Joyce Serafini.)

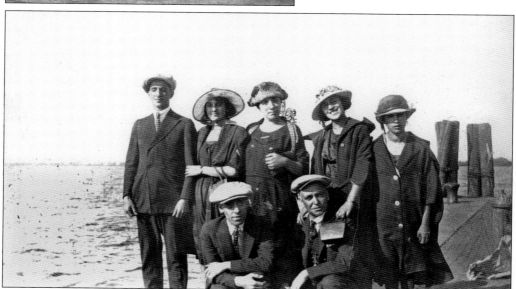

A favorite pastime on a Sunday afternoon was to take a ride "down to the Erie Public Dock." In this picture on Easter Sunday 1924, the Corso sisters are decked out in their Easter bonnets. Kneeling are, from left to right, Joseph Sansone and brother-in-law Anthony Comella; (standing) Sam Corso, Ninfa Corso, Josephine Corso Sansone, Lena Corso Yapello, and Margaret Corso. (Antonina Siggia.)

Ralph Battaglia is shown here as the sponsor of Louis J. Tullio on his confirmation day. Ralph was one of 10 children of Giacomo and Julia Martino Battaglia. His parents came from northern Italy (near Venice). Ralph worked in retail sales of men's clothing. Louis Tullio later became the first Italian American mayor of Erie. (Carol Zimm.)

Pictured here in the backyard of their home at 2215 Plum Street, Paul and Marietta Rigazzi emigrated from Rocca Pia. Paul came in 1915, and Marietta came later with son Anthony in 1921. Paul worked at General Electric, and they had three other boys—Louis, Ester, and Adolth. (Gloria Rigazzi.)

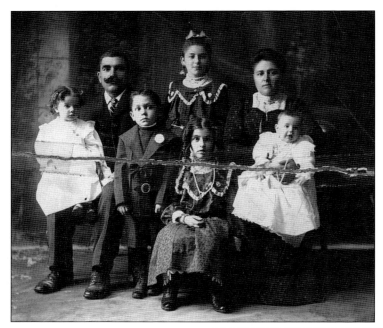

Domenic and his wife, Nicoletta Di Tullio, came from Pennapiedemonte in 1885 and settled in Erie to work on the coal and ore docks. Domenic had a beautiful tenor voice and was called the "Caruso of Little Italy." He is pictured here with his family around 1904. The children are, from left to right, Celia, Jessamine, Adelina with Anne behind her, and baby William. Young Jessamine became a lawyer, one of the first Italian Americans to be admitted to the bar in Erie. (Elaine Fitzgerald.)

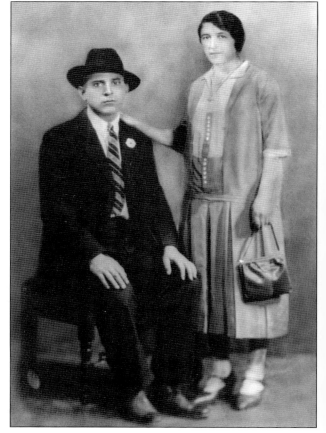

Pictured here are Querino and Elisabetta Letterio in 1927. Querino came to America in 1920 from Rocca Pia, Aquila, Italy. Elisabetta recalled crossing the ocean with her six-year-old daughter, Nicoletta, to be reunited with Querino. She had a trunk with all her treasured copper pots and bedding and a huge rolled mattress. It was a 12-day trip. She was very sad to leave her mother and sister. (Nicolina Cianflocco.)

Godparents Algissa Mariani and Biaggio Verdecchia pose with Carlo Cichetti on his baptism day in the late 1920s. They were among a cluster of Italian emigrants from Abruzzi who resided on the east side of Erie near Twenty-sixth and Brandes Streets and attended Holy Rosary Church. (Al Yezzi.)

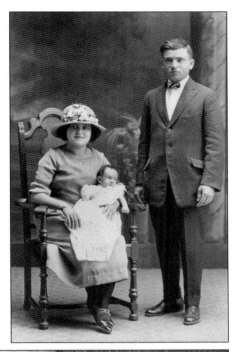

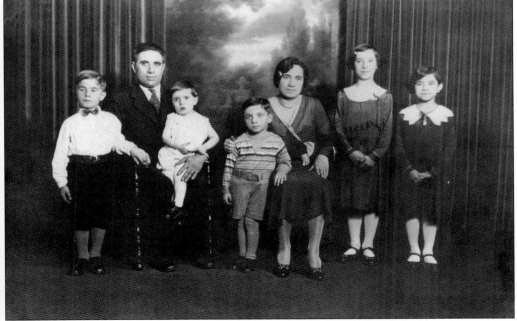

Dominic (Daniel) Carneval and his wife, Antoinette (Anna) Pate Carneval pose with their five children in 1932. Seen from left to right are Robert, Dominic (Daniel) holding John, Daniel Jr., Antoinette (Anna) seated, Josephine (Joan), and Geraldine (Jerry). Not pictured is Vincent James, who was born in 1942. Daniel Jr. went on to become a well-respected physician in the community, and John became a successful business entrepreneur, owning a key, lock, and safe business. (John Carneval.)

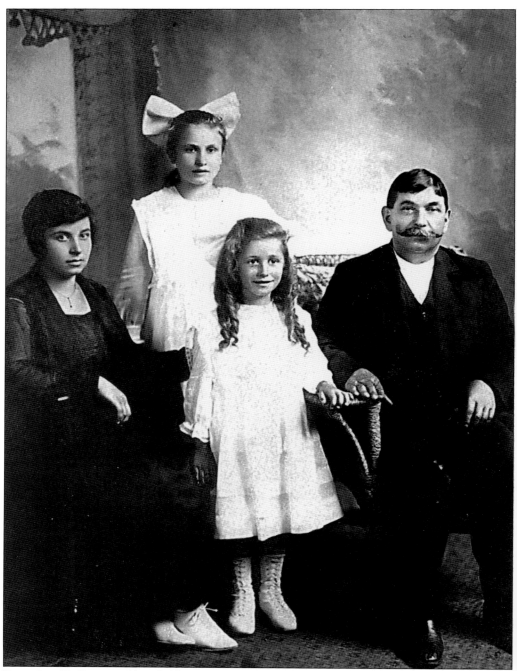

Bernadino Di Santo and his children appear in this c. 1914 photograph. Seen from left to right are (seated) Brigida, Alesina with the large hair bow, Maria, and Bernardino (seated). Bernardino and his wife, Marie Rosa Di Santo, came from Pennapiedemonte in 1912 with their three daughters and settled at 1129 West Fourth Street. This area would come to be known as the "Italians down by the lake." Sadly Maria Rosa died in 1914, leaving Brigida, who was 12 years old, to raise her two younger sisters. (Patty McMahon.)

Eugene and Fortuna Leone Jordano emigrated from Regale around 1910. They raised 10 children at 2204 Plum Street. Eugene went to night school to learn English and mathematics and started a cement and plastering contracting business. In 1918, he became a charter member of the Sons of Italy of Victor Emanuel III. Seated from left to right are Eugene, Anthony, Domenic, John, and Marion; (standing) Thomas and James. Two other children, Mary and Louis, were born later. (Mary Jordano.)

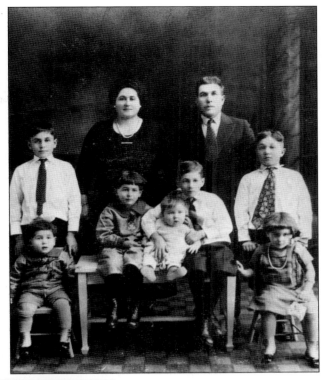

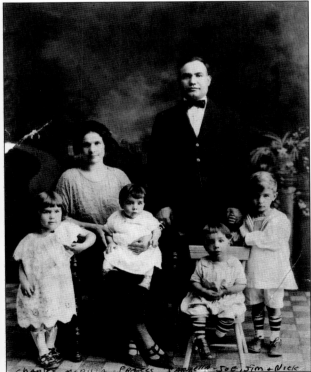

Carmelo and Fortunata Bongiovanni Mobilia immigrated to America from Montalbaro Elicona, Silicy. He was a shoemaker in Erie until the family moved to a farm in North East, a suburb of Erie, where Carmelo established the Mobilia Fruit Farm. Pictured here from left to right are Carmella, Fortunata holding Joseph, and Carmelo; (standing) Vincent and Nicholas. Five more children were born later. (Nancy Hersch.)

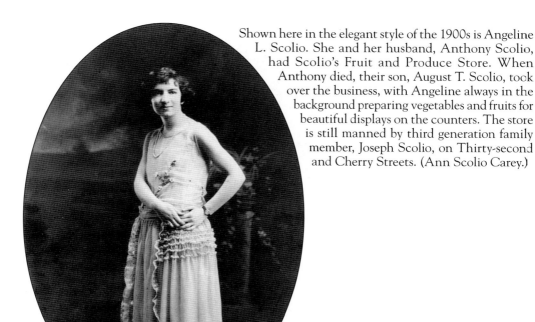

Shown here in the elegant style of the 1900s is Angeline L. Scolio. She and her husband, Anthony Scolio, had Scolio's Fruit and Produce Store. When Anthony died, their son, August T. Scolio, took over the business, with Angeline always in the background preparing vegetables and fruits for beautiful displays on the counters. The store is still manned by third generation family member, Joseph Scolio, on Thirty-second and Cherry Streets. (Ann Scolio Carey.)

Phyllis D'Aurora Perfetto, shown here in 1930 at age 21, was one of 11 children of Pasquale and Concetta (Amatangelo) D'Aurora. Phyllis had a flair for fashion, as she is seen here in the latest flapper look! (Fran Konkol.)

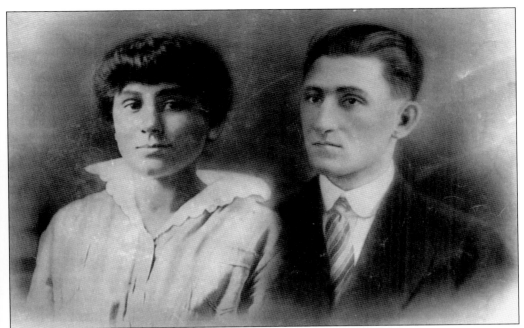

Shown here in their engagement picture in 1916 are Lawrence Fatica from Abruzzi, Italy, and Laura Monda, originally from Naples. After marriage, they settled at 556 West Sixteenth Street. They had seven children. Mr. Fatica did maintenance work at Erie City Hall. (John Fatica.)

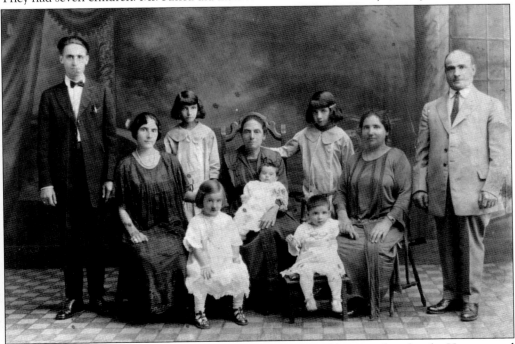

Grandma Vincenza Chiapazzi Giliforte holds the newest addition to her family. Her son and daughter-in-law with two other children are on the left. A daughter, son-in-law, and two children are on the right. Exact names could not be identified. (Joyce Serafini.)

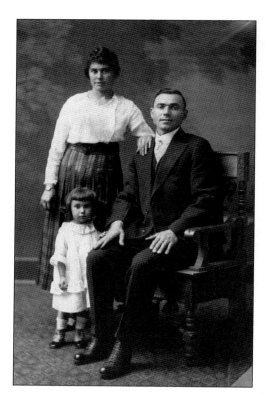

Anthony F. Di Placido arrived in Erie from Pennapiedemonte, Abruzzi, Italy, in 1909 at the age of 15. He is shown here with his wife, Marietta De George, whom he married in 1916, and daughter, Ann, at three years of age. Two other children came later, Florence in 1921 and Donald in 1924. Anthony was a skilled self-employed plaster man. (Jeanette Spinelli.)

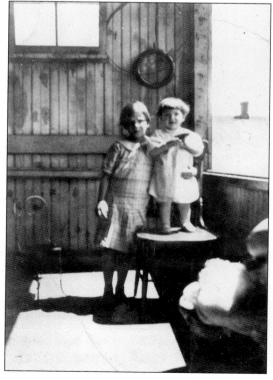

Olga Giusti, daughter of Oreste and Dalida Giusti, emigrants from Tuscany, supports little Norma Palandro as she stands on a chair on the third-floor porch in the 400 block of West Sixteenth Street. Buildings were close together; there was not much of a play area, so the girls spent a lot of time playing there and looking over the railing, watching the comings and goings of people as they passed by on the sidewalk. (Norma Palandro Webb.)

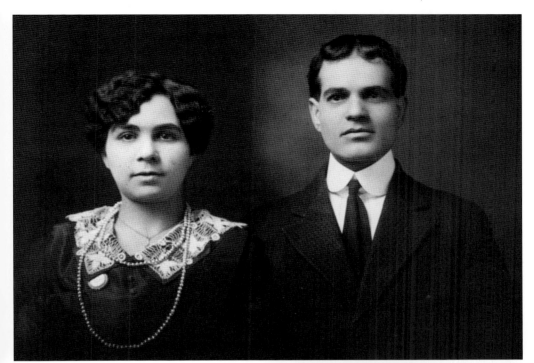

Leonard Pinzarrone and his wife, Antoinette Calaciura, were emigrants from Agrigento, Sicily. They lived at Seventeenth and Hickory Streets. Leonard was a shoe repairman by trade. However, when he was at leisure, he was always dressed in the latest men's fashion, taking great pride in his appearance. He and Antoinette made a handsome couple. (Courtesy Julie Shadeck.)

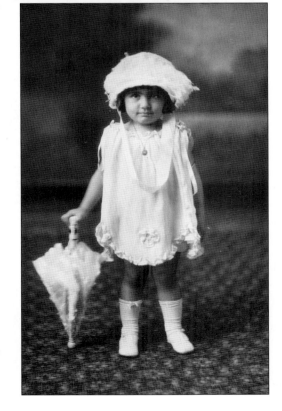

Pictured here is three-year-old Julie Pinzzarrone all ready for the 1926 Easter parade. Julie was the only child of Leonard and Antoinette Pinzarrone (above), who took great pride in dressing their daughter in an "American style." The contributor stated that after so many years, the little umbrella is still in perfect condition. (Julie Shadeck.)

In a photograph taken in 1926 are Mary (standing), age four, and Rose (seated), age three. Their parents were Antonio and Saveria Quattrocchi Parisi, emigrants from Silicy. Domenica (Mamie), a third child, was born in 1924. "Donna" Saveria, as she was called, was widowed at an early age. She remarried in 1930 to Umberto Chemi. He was a good father to the young children. The family lived on West Seventeenth Street for many years. (Victor Savelli.)

Pictured here is Domenico Troppichini holding baby Lena with his wife, Louisa (Santini), sitting in front of their home at 456 West Seventeenth Street. Rita, standing, holds her mother's hand around 1931. Domenico and Louisa Troppichini came from the town of Montefiascone, Italy. Domenico served in the U.S. Army as a corporal in World War I. (Rita Schemeck.)

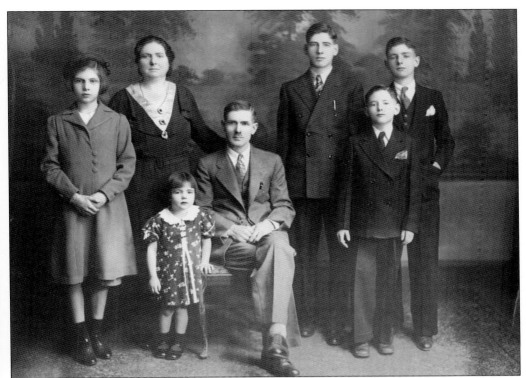

For Christmas 1938, the Salvatore Vitelli family posed for a portrait at Vagnarelli Studio in the 400 block of West Eighteenth Street. Standing from left to right are Lydia, Rosa Vitelli, Anthony, and Lidano. Rena stands next to her father, who is seated. On the right is Silvio. In 1942, the family bought a home at 249 West Twenty-third Street. Salvatore was proud of his large garden and grapevine-covered patio. (Rena Wierbinski.)

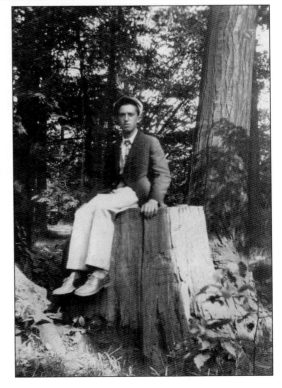

Peter Manucci takes a rest on a tree stump while walking in the woods in 1925. Peter was a talented carpenter. (Audrey Walker.)

Enjoying a relaxing moment on their porch are Urbano Cerio and his wife, Lisandrina Maria (Sivillo) Cerio, around the 1940s. Both were born in Matrice, Campobasso province, in 1884. They lived at 439 West Sixteenth Street. Urbano and a friend, Tony Gambatese, built a wine press out of railroad ties. They bought a truckload of California grapes, ground and pressed the grapes as they sang and told jokes, and made five large barrels. They also had a bountiful garden. (Charles Tavernese.)

Dante's Café was operated by Andrew DeDionisio in the 1950s. Shown from left to right are Ralph Battaglia, owner of Taggart's Men's Store and Andrew's brother-in-law; John DeCecco, who owned the building in which Dante's Café was located; and Don Rogala, Andrew's best friend, who introduced Andrew to his future wife. (Diane DeDionisio Davies.)

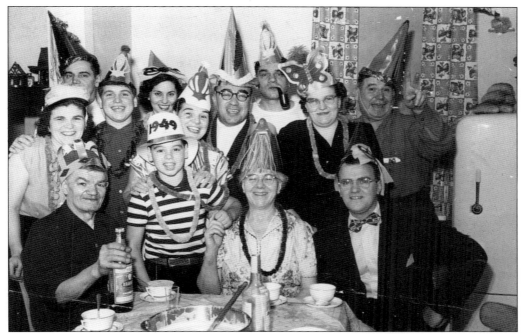

Family get-togethers were important occasions among Italian families. Shown here celebrating New Year's Eve, 1949, are the Angelotti family. Constantino, the patriarch, is seated on the left. Leaning over his shoulder is daughter Catherine Nedresky; Anita Di Vecchio is far right with the Hawaiian lei necklace. Others are unidentified. (Lena Soccoccio.)

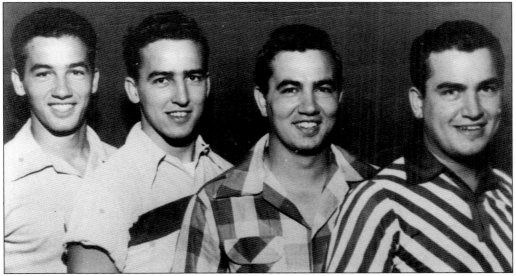

Pictured here are the four Catania brothers, from left to right, Joseph, Carmen, James, and Charles. Their dad, Giuseppe, emigrated from Maro, Montalbano, Sicily. He married Maria Millemaci in St. Paul's Church in 1922. Joseph and James live in California, and Carmen lives in Denver, Colorado. Charles lives in Erie, retiring from Erie Malleable Iron as human resources director. Charles is also a history buff, especially concerning Italian history and social organizations. (Charles Catania.)

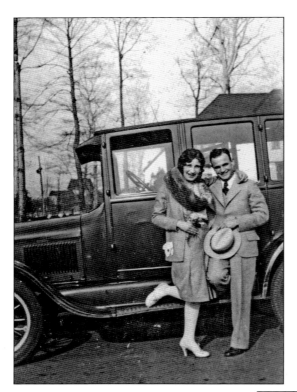

Ralph Battaglia and Nancy DiDionisio are pictured here posing in front of Ralph's four-door vehicle in 1934. Engaged to be married, they made a handsome couple. Ralph worked in retail sales at the Boston Store and later owned Taggart's men's store. (Carol Zimm.)

Pictured here are Carl and Rose Massello Rossi on their honeymoon at Niagara Falls in the winter of 1913. Notice the falls are frozen over. Carl came to America in 1890 from Montelungho, Campobasso, at the age of 15. He became a professional realtor and businessman. Carl and Rose were active parishioners at St. Paul's Church for many years, heading many committees and doing good works. (Carol Costello.)

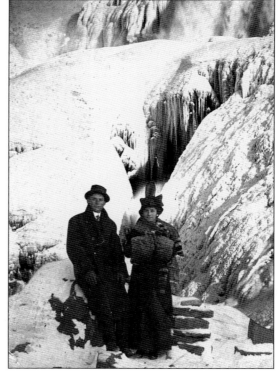

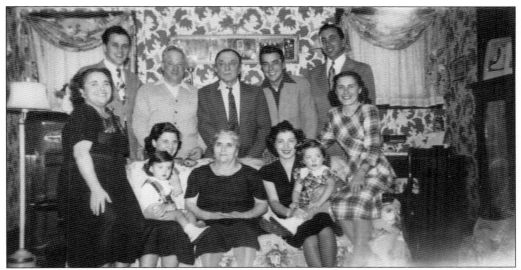

Shown here at a Christmas family gathering in 1950 is the Domenic Gianoni family. Shown from left to right are (first row) Ida Gianoni Duchini, Carrie Gianoni holding daughter Linda, Zelinda Gianoni (matriarch), Helen Gianoni with daughter Joyce, and Dorothy Gianoni; (second row) Guido Gianoni, Avelino Duchini, and Domenic, Albert, and James Gianoni. Mr. Duchini started the Duchini Cement Block Factory in southeast Erie. The family had Tuscan roots. (Jim Gianoni.)

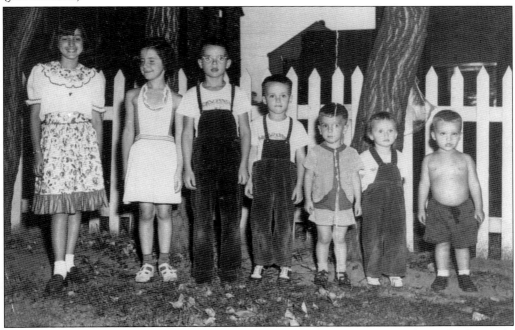

Pictured here, from left to right, are Eleanor Cutri and her cousins—Marilyn, Charles, Bob, Kathy, Skip, and Billy Agresti—in their uncle Richard's yard in 1949. After mass each Sunday, the families would gather at grandpa Egidio Agresti's house, and after dinner, he would engage all in a lively discussion of current events. Later, in the 1970s, Eleanor Cutri served as president of the National Organization of Women. (Atty Charles Agresti.)

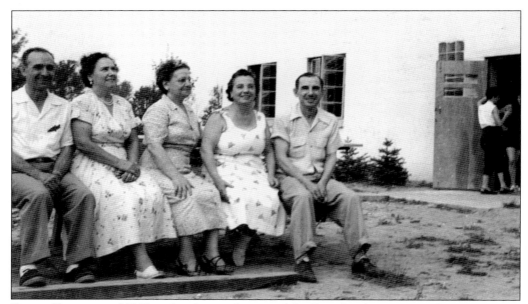

Pictured here around 1940 are brothers and sisters of the Corsi family, emigrants from near Sezze. Shown from left to right are Ludwig, Marietta, Bianca, Quintina, and Louis. Bianca was an excellent cook whose ravioli and homemade pasta specialties were in great demand by restaurants. Bianca was 14 years old when she married Lorenzo Pieri in 1912. It was an arranged marriage. They had not met until their wedding day. (Margaret Pieri.)

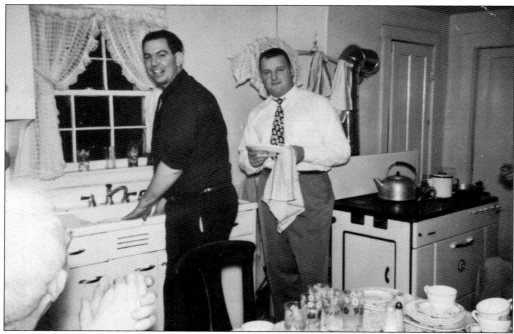

Shown here are Lou Tullio (right) and his friend Joe Whitney sharing kitchen chores. Lou met his wife, Ceil, while attending Holy Cross University. They returned to Erie, and later Lou entered politics and became the first Italian American mayor of the city of Erie. (June Pintea.)

Guido Pieri, son of Lorenzo and Bianca Pieri, stands by the mailbox on the corner waiting to hang out with his buddies. Telephone poles on most corners had a mailbox until the late 1950s, when they were replaced with standing boxes. People could just walk a short distance to mail a letter. There was only one post office, and it was in the Griswold Plaza. (Margaret Pieri.)

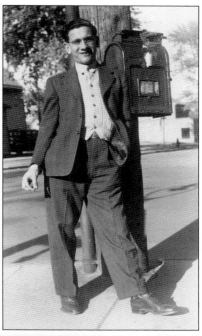

Relaxing on the front porch of their home at 423 West Seventeenth Street are, from left to right, Jean Malizia DePalma, Gloria Malizia Rigazzi, Carol Ann Malizia Sobolewski, and Patrick Malizia in 1943. Sister Nicolina is not pictured. They were the children of Italia and Luigi Malizia. Gloria's biological mother, Cesaria Arcoletti Moresco, died when she was born, and her aunt and uncle, Italia and Luigi Malizia, raised her. (Gloria Rigazzi.)

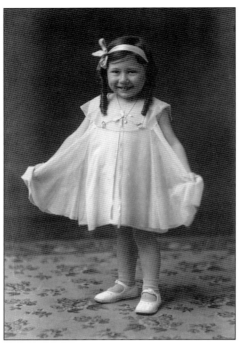

Ready to take a bow on her fifth birthday is Yolanda Ruscitto, youngest of six children of Giuseppe and Angelina Galenti Ruscitto of Petrella, Campobasso, Italy. Yolanda is dressed "alla Americana" (American style). Italian mothers soon adapted to styles and norms of American life. "We are in America now," was an often repeated statement. (Joseph Ruscitto.)

The three children pictured here from left to right are Audrey, Anthony, and Marianne Vendetti, children of Carmen Vendetti and Anna Dal Porto. Carmen was a cement contractor. There are many sidewalks in the city with a small brass plaque with Vendetti Construction Company engraved on it. Carmen and Anna were first-generation Italian Americans. (Lisa Urraro McLellan.)

Pictured here are Ernest J. Di Santis and his wife, Grace, holding their son, Ernest J. Di Santis Jr. Young Ernest grew up to be an attorney and the first Erieite to be named to a federal prosecutor's office. He later became a judge in the court of common Pleas. His immigrant grandparents would have been proud. (Grace Di Santis.)

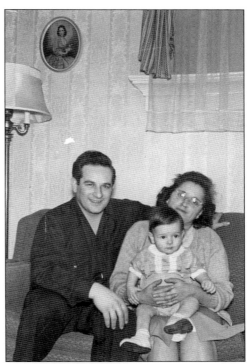

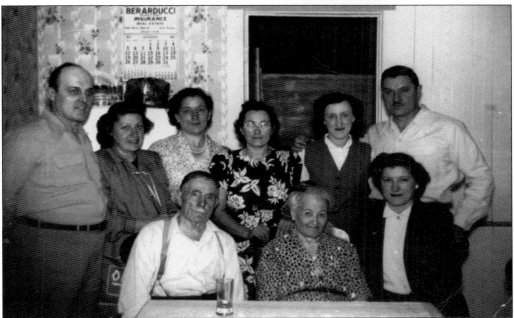

The DiPaolo family stands behind their parents, Domenico and Laurena, and sister, Rose. From left to right are Pasquale, Eleanor (DiPaolo) Pepicello, Louise (DiPaolo) Covatto, Mania (DiPaolo) Ciampiglione, Josephine (DiPaolo) Touris, and Anthony. The DiPaolo family resided at 1407 Liberty Street. Domenico and his paesani formed a Rocca Pia club. Domenico was a great winemaker and was proud of his large garden with 500 tomato plants. (Courtesy Dominic DiPaolo.)

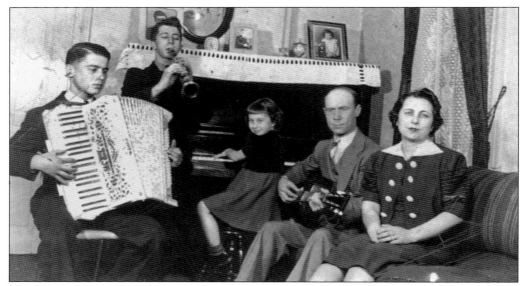

The Oreste Bagnoni family loved to get together and make music. Shown here in 1939 is Mario with a clarinet, Walter playing the accordion, and Rita at the piano. Oreste plays the guitar as proud mama Doris looks on. Mario was born in Tuscany, Italy. He came to America with his parents in 1922 as a baby. Mario became a professional musician and played with several bands during the big band era. (Rita Chizmadia.)

Helmar "Elmer" Spadacene plays the mandolin as brother Edward listens while they take a break from working the family vegetable plots. Elmer was also a talented violinist and played with the Erie Philharmonic Orchestra. Their parents were Amadeo and Giulia Manzi Spadacene, emigrants from Tuscany, Italy. Before West Twelfth Street became an industrial corridor, many immigrants used the land to grow vegetable gardens. (Barbara McNamara.)

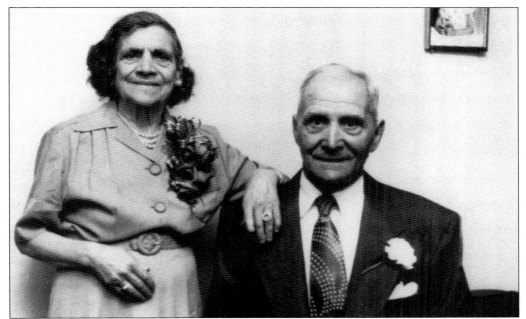

Pictured here are Giuseppe Valenti and Nicolina (Patamia) Valenti on their 50th wedding anniversary in May 1954. Both immigrated to the United States from Crichi Semeri, Italy. Mr. Valenti worked at Cascade Foundry. The family lived on Huron Street and then moved to 533 West Sixteenth Street in the heart of Little Italy. It was the family homestead until their deaths. (Kathleen Marton.)

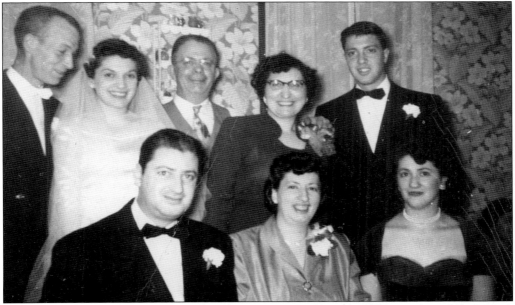

In 1952, Catherine Bellucci married Ted Johnson, a fellow teacher at Roosevelt Middle School. Celebrating the occasion at her father Giuseppe's home, from left to right, are (seated) Gerald Bellucci, Angelina Bellucci Wickham, and Louise Bellucci Cantoni; (standing) the happy couple, Giuseppe Bellucci, Carmelina Bellucci, and Edward Bellucci. (Dennis Cantoni.)

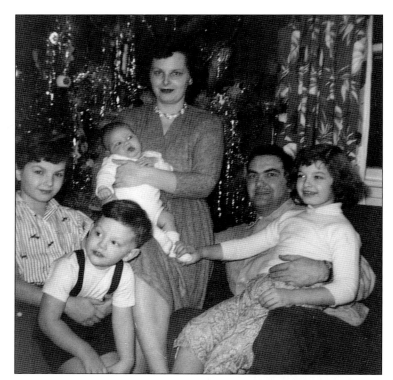

Children made their own Christmas ornaments and strung popcorn for the tree. Here Robert Lee (owner of the American Theater) is with, from left to right, Sandra Lee; Robert (Chipper), Irma Lee holding David, and Lyn. Dolores Lee Sabino was born later. Robert's parents, Giovanni Lea and Margherita Demangone, emigrated from Mercenasco. (The Lee family.)

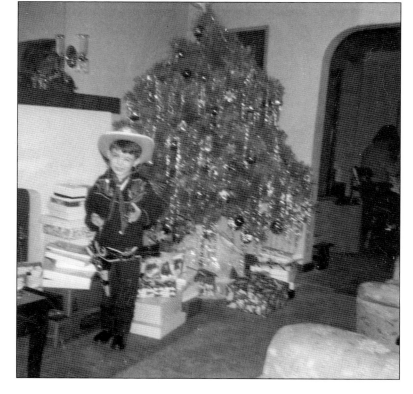

Five-year-old David Masella stands in front of the Christmas tree in his cowboy regalia complete with holster and six shooter. His parents were Ercole Masella of Onano, Italy, and Susan Cionco, whose parents, Liberato and Delia Cionco, came from the same town as Ercole. (David Masella.)

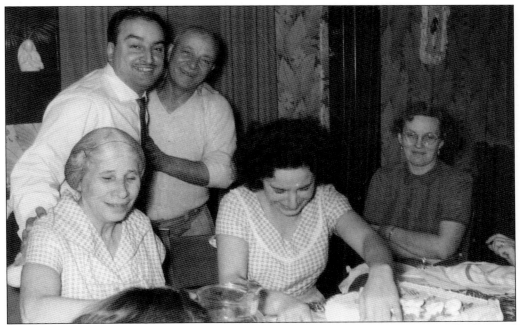

In this 1955 photograph, the family gathers to celebrate Rose Palermo's birthday at the home of Rose and Salvatore Palermo, 244 West Sixteenth Street. Shown from left to right are Rose LaBrazi Palermo, Vince Palermo, Salvatore Palermo, Josephine Palermo Capozziello DeLuca, and Ruth Timper. Salvatore made homemade Sicilian sauce every Sunday. (Vince Palermo.)

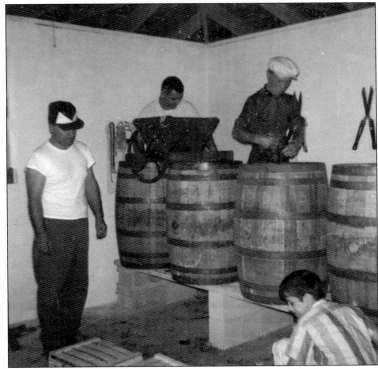

Making wine—buying (or growing) the grapes, pressing them, and fermenting them—was a great tradition in many Italian households. Here wine making is underway at the home and garage of Armello "Oreste" Bagnoni on 4431 Peach Street. Shown from left to right are Vince Palermo, Jim Chizmadia, Armello Bagnoni, and Steve Bagnoni. (Vince Palermo.)

Many families in Erie got help from the Erie County "Poor Board" during the 1930s. Pictured here are Rita (left) and Lena Troppichini in their back yard with dresses made from bolts of fabric and shoes that the family received from the Poor Board. A distribution center was located on the second floor of a building on the corner of Tenth and Peach Streets. (Rita Schemeck.)

Every child in Little Italy wanted to have their picture taken by the traveling photographer and his pony. Here in 1943, Rocco, son of Lena Corso Yapello and Joseph Yapello, poses as a cowboy. As a young adult, he won the Italian American Bowling Championship Tournament. He served honorably as a U.S. Marine and worked at General Electric before moving his family to Florida, where he became a landscaper. (Antonina Siggia.)

Two
WORK AND PROFESSIONS

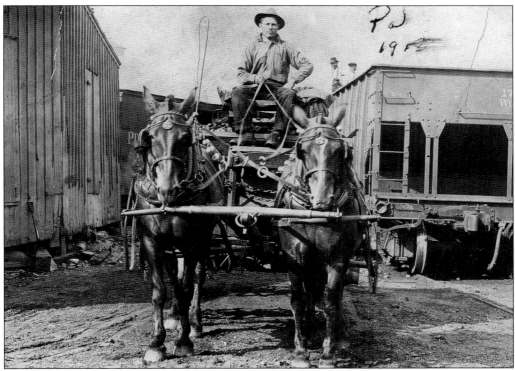

Anthony Pallotto is shown on his horse-dawn wagon delivering coal for Gebhardt Coal Company, located at Twelfth and Sassafras Streets in Erie. Most residences heated and cooked with coal. Anthony also worked for Erie Malleable Iron. When he was laid off, he opened a Red and White grocery store at Twenty-ninth and Washington Streets. He became an American citizen in 1923. Anthony emigrated from Montenero, Italy, in 1913. (Nance Hoffman.)

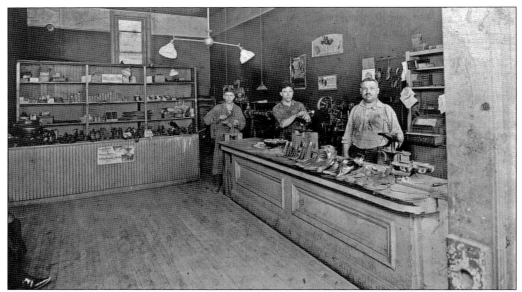

After Luigi Malizia was wounded in World War I, he went to a rehabilitation program to become a shoemaker. Later he worked in the Erie County Courthouse for 30 years and was a familiar figure there. (Gloria Rigazzi.)

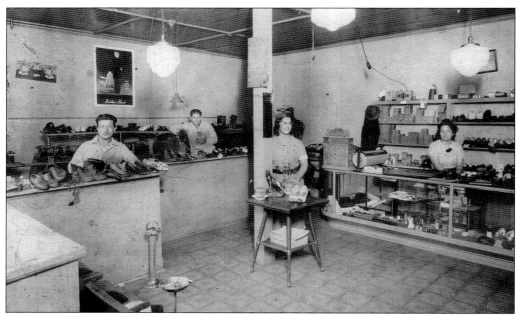

Standing at left, Luigi Di Martino, from Marchenese, Calabria, was a skilled cobbler. His shop, Master Shoe Repair at 8 West Eleventh Street, specialized in adapting shoes for foot deformities. He was also sought out by professional tap dancers for applying "taps" for a precise sound. His is pictured here with his wife, Mary Purvi, standing in the center. He had four children, Pasquale, Williams, Louis, and Antoinette. As a widower, he and his second wife, Josephine, had a son, Joseph. (Ann Woodward.)

Battista Madonia, an emigrant from Teresina, Sicily, established a popular bakery and grocery store on West Eighteenth Street in two locations before settling in a larger building at 450 West Eighteenth Street. He and his wife, Rose Rizzo, also from Sicily, worked in the store together while raising a family of three children. They imported many Italian specialty items, as well as selling good meats and delicious loaves of Italian bread. (Grace Madonia.)

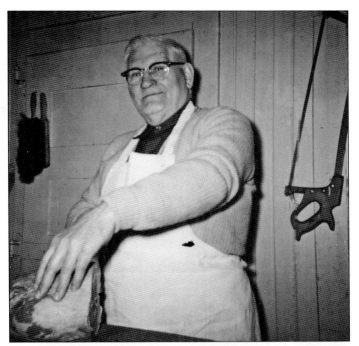

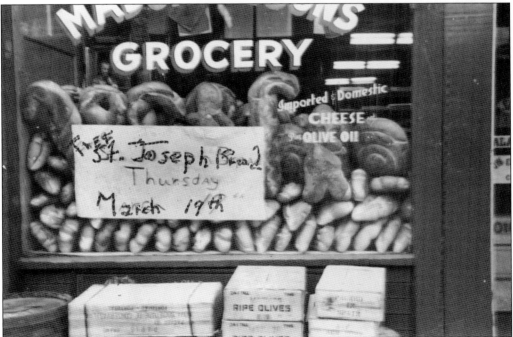

Pictured here is Madonia's Bakery and Grocery store, advertising "free bread for St. Joseph's Day, March 19." Battista Madonia, the owner, had been involved in an automobile accident, and a young boy was badly injured. St. Joseph came to Battista in a dream and told him that the boy would live. In honor of St. Joseph, he distributed blessed bread to all, including the Carmelite Monastery and the Sisters of St. Joseph. (Grace Madonia.)

Giuseppe Vercillo is shown here at the age of 17 in 1939 in Italy, giving a customer a permanent wave. He was a barber and hairdresser. He stated this was one of the first methods using electrically heated rods. When Giuseppe came to America in 1956, he also owned a stamp and coin shop. As a talented cook, he catered home dinners too. He was a jack of all trades. (Joseph Vercillo.)

Giuseppe Vercillo was born in 1919 in Asti, Piamonte, Italy. He was a barber by trade and established a barbershop at 326 West Eighteenth Street. He is shown here on the right, with fellow barber Domenic Silvaggi. Giuseppe was a soldier in the Italian Alpine Army and fought against the Nazis during World War II. He was captured by the Germans and imprisoned for two years. He came to America in 1956. (Joseph Vercillo.)

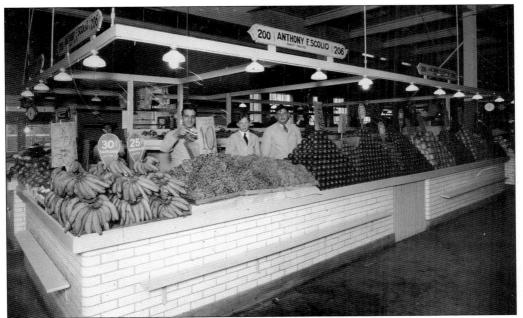

Several Italian immigrants had produce stands in the Erie Central Market, located between Peach and State Streets. It had many stalls selling live chickens, meats, cheeses, olive oil, and other fresh foods. Pictured here is the Anthony F. Scolio stand. The owner, Anthony, was nicknamed "Okie" because he had gone to Oklahoma for a period of time to find work. He may be one of the three men behind the counter. (A. J. Scolio.)

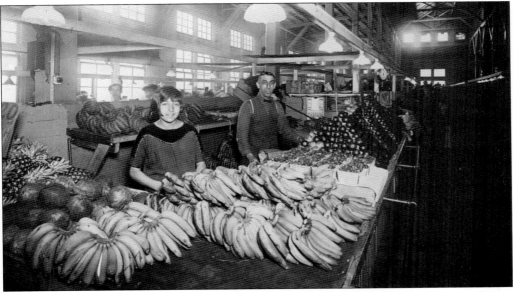

Joseph Sansone was one of the very early immigrants to settle in Erie. He was born in 1884 in Termini Immerese, Sicily. He and his wife, Josephine Corso, were married in 1910. Joseph is shown here with his daughter, Lucy, age 12, behind their stall at the Erie Central Market on Sixteenth and State Streets in 1925. It was not unusual for children to help out in the family business. The market closed its doors in 1958. (Marion Sansone.)

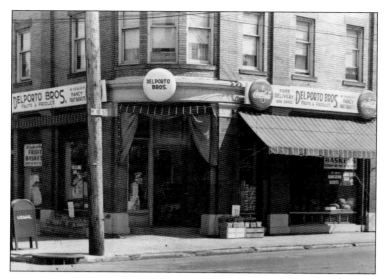

Pictured here is the store front of Del Porto Fruit and Produce Company. The owners were Louis and Sam Del Porto, sons of Gioacchino Del Porto, an emigrant from Tuscany, Italy, who sold fruits and vegetables from a push-cart in Little Italy in the early 1920s. The store was located on the northeast corner of Eighteenth and Sassafras Streets. (Sam Constantino.)

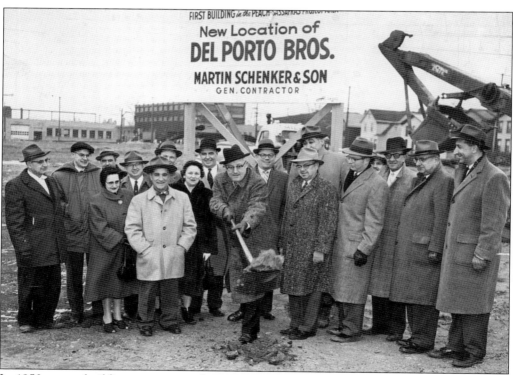

In 1950, many buildings were torn down on Peach and Sassafras Streets to make room for redevelopment. Del Porto Brothers Fruit and Produce relocated to this area on the southwest corner of Eighteenth and Sassafras Streets. Turning over the first shovelful of dirt is mayor Arthur Gardner. Sam Del Porto stands to his right in the light-colored coat. Mary, Sam's wife, is directly behind him on his left. Many family members and city officials were present for the ground-breaking. (Sam Constantino.)

Edward C. Di Michael was the son of Joseph Di Michael, a native of San Angelo, Calabria, and Mary Di Nunzio, whose parents came from Abruzzi, Italy. He is shown here making his signature square pizza at his restaurant at 710 West Eighteenth Street in 1947. It was the only pizza shop in town at that time. (Roberta Di Michael.)

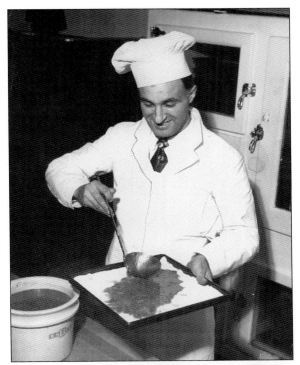

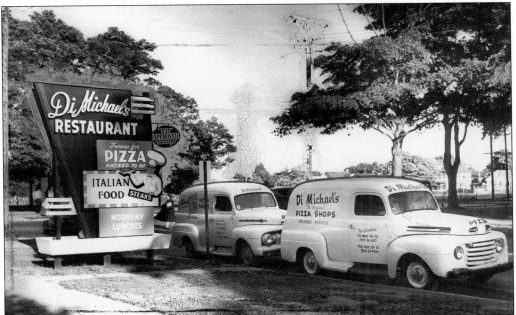

Here is the fleet of Di Michael's Pizza shop vans. Edward Di Michael was the first pizza shop owner to offer delivery service in the late 1940s and 1950s. Pizza shops began to flourish in the United States after GIs returned home from World War II. They were influenced by the pizzas of Italy. Di Michael's was the first shop in Erie. Ed was also the first to offer frozen pizzas to take home. (Roberta Di Michael.)

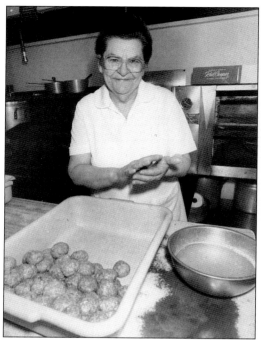

Angeline Marinelli Di Tullio is shown here making her signature meatballs for the restaurant she co-owned with her husband, Hector. Her Italian cooking was first rate, and many sports celebrities came there to eat. Famous autographed pictures of sports figures lined the walls of Hector's, with names such as Joe Di Maggio, Ted Williams, Joe Paterno, Fred Biletnikoff, Gov. Dick Thornburgh, Gov. Robert Casey, and many more. (Esther Gallagher.)

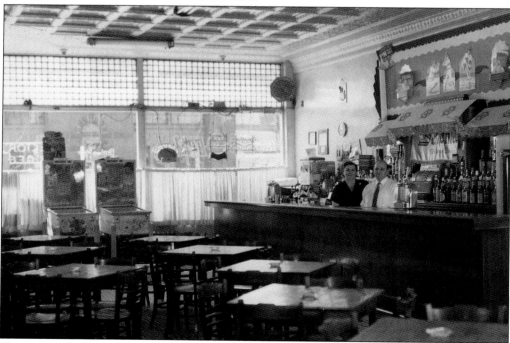

Shown here behind the bar at Hector's on Eighteenth and Liberty Streets are Hector Di Tullio and his wife, Angeline. Hector was a musician by trade, but he always dreamed of having a bar. He started the business in 1943. With Angeline behind the scene cooking the Italian food, it became a big success. Hector's sponsored many athletic events such as little leagues and bowling teams and was very active in the Italian community. (Esther Gallagher.)

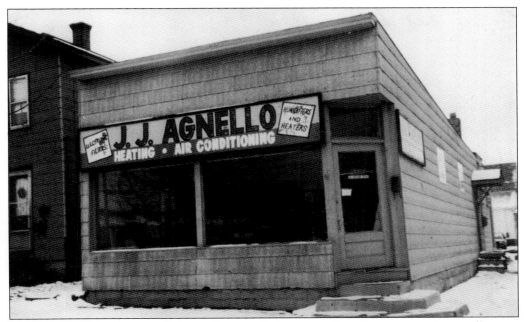

In 1952, young entrepreneur John Agnello started a heating and cooling company in a small garage at 1515 Chestnut Street. His parents, Giovanni and Josephine Agnello, emigrants from Sicily, instilled a strong work ethic in their children. After John died, his three sons, present owners, expanded this very successful business to Sixteenth and Liberty Streets. Their mother, Eleanor Yapello Agnello, is still a valued "consultant." (Eleanor Agnello.)

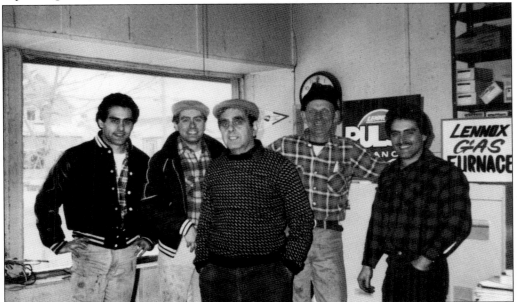

Pictured here is John Agnello, owner of Agnello Heating and Cooling Company, with his three sons. The boys worked for their father and continued as owners after their father passed away. Seen here from left to right are Phillip, Anthony, John (dad), Paul Kuchner (an employee), and Thomas. (Eleanor Agnello.)

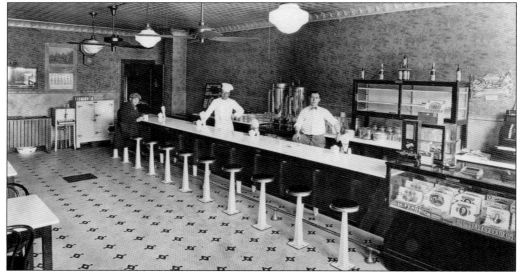

The Rex Restaurant, located on Sixteenth and Walnut Streets, was established around 1927 by the Angelo Mazzeo family. The second floor had elegant booths with a large wait staff who wore bow ties. Celebrities dined there. Primo Carnera, an Italian heavyweight champion, made an appearance before a large enthusiastic crowd in 1933. Shown here behind the counter are the cook, Albert "Curly" Maracci in chef's hat, and Jess Mazzeo, son of Angelo. (Dora Mazzeo.)

Lidano Adiutori, an emigrant from Acuto, Italy, is shown here (with the butcher's cap) behind the meat counter of his grocery store at Sixteenth and Chestnut Streets in Erie with daughter Philomena and wife Mary. There were six children in the family, and they helped in the store as well as at the Central Market on Peach Street, where Lidano also had a stand for meats and produce. (Larry Adiutori.)

In the early 1930s and 1940s, there was a grocery store on just about every block. One such store was Berarducci and Clemente's at 1618 Walnut Street. Standing at a display of Kirkman soap, "Today's Buy" for 31¢ a box, is Frank Berarducci and his young daughter, Antoinette. Children usually helped out after school and on Saturdays working in their parents' stores. (Antoinette Mucci.)

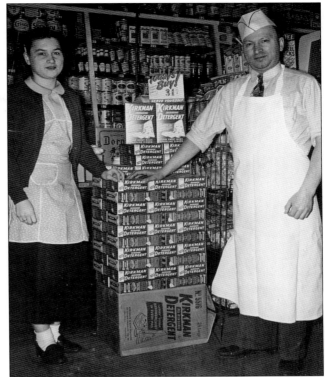

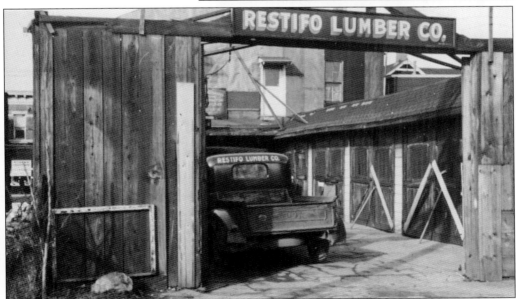

Anthony Restifo, born in Italy, served in the U.S. Army during World War I. He was a carpenter. After the war, he founded Restifo Lumber Company at 455 West Eighteenth Street. There was a building boom after World War I, and he sold lumber to many contractors for home construction and alterations. Later he added finished and unfinished furniture in the mill store front. His wife, Mary Palmisano, continued running the business after his death. (Carol Restifo.)

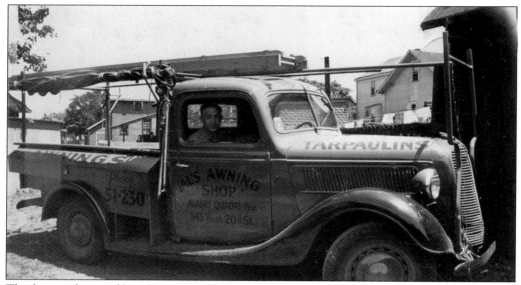

The first truck owned by Al's Awning Shop was a used Ford and was painted with donated orange and black paint, colors that were then used through out his ownership. The year 1946 marked the expansion of his awning business. (Fran Quadri.)

Shown from left to right are David Quadri, Albert Quadri, and Dick Quadri. Al Quadri started an awning business in a garage at 943 West Twentieth Street. He repaired and made truck tarps and house awnings. Sons David and Dick joined their father and expanded to a location at 1721 West Twenty-sixth Street. Lillian Sabatini Quadri, their mother, and other relatives also worked in this family business. Both Al and his wife Lillian's parents were from Tuscany, Italy. (Quadri family.)

Joseph Agresti was one of four children of Egidio and Angelina Scalzo Agresti. He graduated from the University of Pittsburgh Law School in 1936, practiced in Erie, and was a community leader for 63 years. His father was a strong believer in education. Joseph's brother Adolf became a pharmacist, his brother Richard became an attorney, and his sister Dorothy managed a drug store chain. Joseph's son Charles and grandsons Michael and David are also practicing attorneys. (Atty. Charles Agresti.)

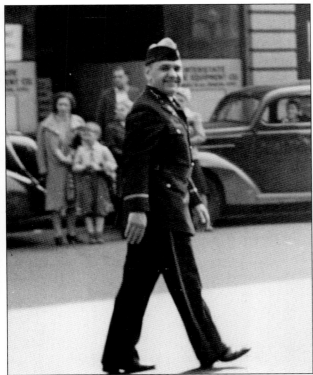

Jessamine Juliante, born in 1899 of Italian immigrants, graduated from Old Erie High School at age 15. He then entered Wharton School, University of Pennsylvania. After World War I, he attended law school, graduating in 1922. He was a deputy attorney general for the state of Pennsylvania in 1935. He and his wife, Rose, had three children, attorney Jess S. Juliante Jr., Joyce, and Joan. He is shown here marching in an American Legion parade around 1940. (Fran Quadri.)

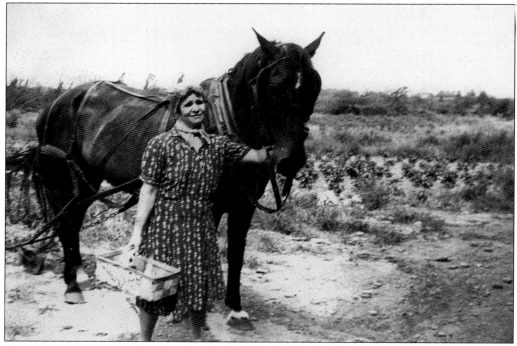

Working on a farm was a family affair. In addition to homemaking chores, mothers often pitched in to do their share. Shown here is Fortunata Mobilia working the fields with a horse. The family had a fruit and produce stand in North East, Pennsylvania. (Nancy Hersch.)

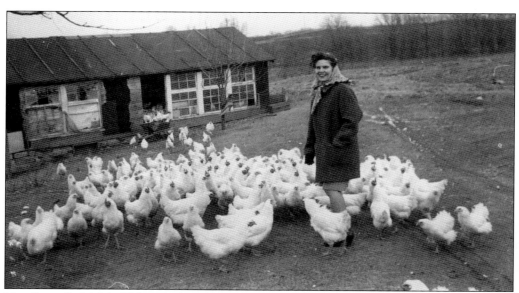

Here Carmella Mobilia Hake is feeding the many chickens on her parents' farm in North East. She was one of nine children of Carmelo and Fortunata Mobilia, emigrants from Sicily. (Nancy Hersch.)

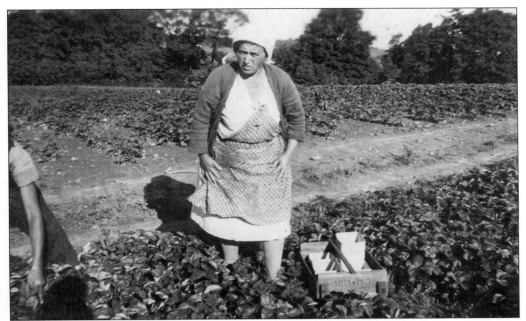

Here Christina Evangelista Bartone is working in a strawberry patch. She and her husband, Feliceantonio, were emigrants from Campobasso, Italy. The couple had a produce stand at Erie Central Market. Mr. Bartone died at the age of 49 years, and Christina then made a living to support her six children supervising vegetable and fruit pickers at various farms. Wages were as little as a dollar a day. She later had a grocery store at Sixteenth and Cherry Streets. (Bettie Veschecco.)

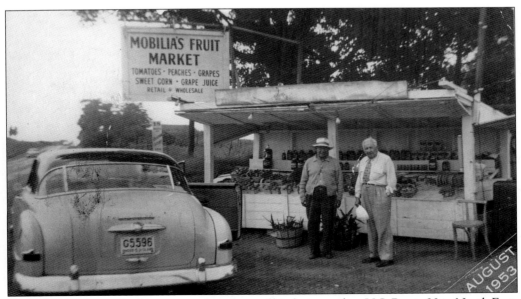

Carmelo Mobilia, with a hat on, stands in front of his fruit stand on U.S. Route 20 in North East. The customer is identified as Warren Grogan. Carmelo, an emigrant from Sicily, was a shoemaker in Erie's Little Italy before moving his family to a large farm in North East. The family later also established Arrowhead Winery, still in existence today. (Nancy Hersch.)

Shown are Liborio ("Bobo") and Rose Giamanco Arnone on a vacation in the Bahamas. They owned Arnone's Importing Company at 601 West Seventeenth Street. It was a popular store for delicious cold meats, imported cheeses, and Italian groceries. While visiting in Las Vegas, Nevada, he became friends with a musician who introduced him to Frank Sinatra, who on learning of Bobo's store began ordering all his favorite Italian food from him. They developed a long-standing friendship until Sinatra's death. Bobo's son, Anthony, continues the tradition of selling quality Italian foods on the corner of Eighteenth and Cherry Streets. (Anne Arnone.)

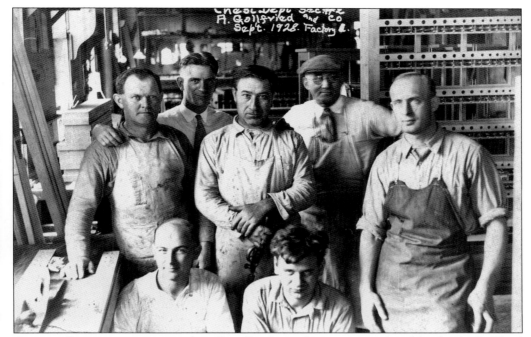

Giuseppe Ruscitto, an emigrant from Petrella, Campobasso, was employed by the A. Gollfried Organ Company on West Thirty-second and Poplar Streets. Later it became Durst Organ Company. He is shown in the center of the second row of fellow workers. Giuseppe was a skilled carpenter and craftsman. He later went into the home construction business with the help of son, Joseph, who followed in his father's footsteps as a builder. (Joseph Ruscitto.)

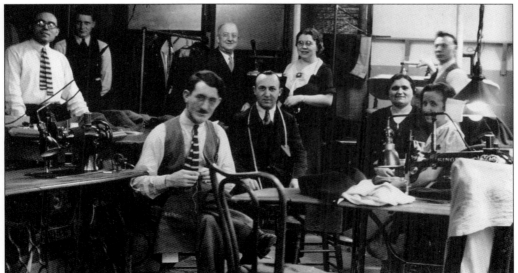

This was the tailor shop at P. A. Meyer's Men's Clothing store on State Street in Erie in the early 1940s. It was an exclusive store with "fussy" customers, but the talented Italian tailors did precise alterations. Standing at left is Charles DiPlacido. Seated from left to right are Oreste Sambuchino, head tailor Angelo Tavani, Francesca Salvagnini, and Marietta Tavani. Others are unidentified. (Norma Palandro Webb.)

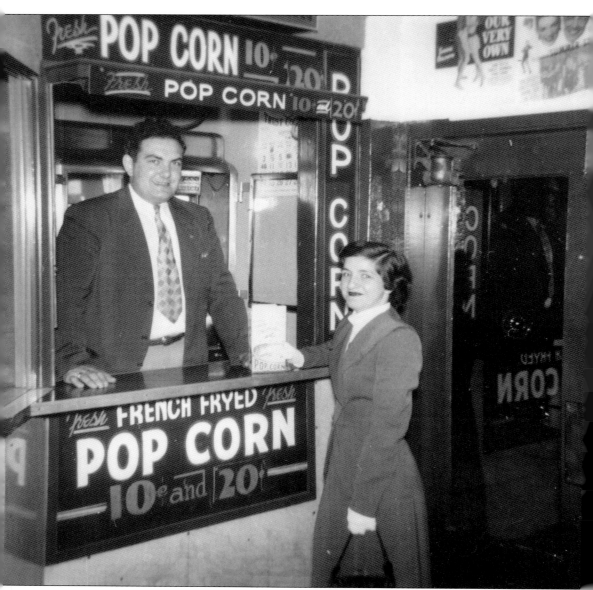

Robert Lee, recently married and a young father, purchased the American Theater on West Eighteenth Street in 1946. He was the oldest child of Giovanni Lea and Margherita Demangone, emigrants from Mercenasco who had settled near Mount Pleasant. Sometimes he would let children in after the movie started if they could not afford the admission. In the mid-1940s, movies were 15¢, and usherettes made 35¢ an hour, with a free box of popcorn when they got off at 9:30 p.m. A group of children from the former St. Joseph's Orphanage, led by a priest, would come to the American Theater for free Sunday afternoon movies. Later Robert worked as an accountant and had his own tax business, advising many Erie-area companies. (The Lee family.)

A product of Little Italy, Joyce Savocchio often worked in her father's store. She fondly recalls the thriving businesses that existed in Little Italy, such as International and Majestic Bakeries, Henry's Ice Cream Shop, Harriet's Wedding Favors, and Oswald D'Aurora's Barber Shop. Elected for three terms as mayor of Erie, she represents the perseverance and accomplishments of Italian immigrants. (Joyce Savocchio.)

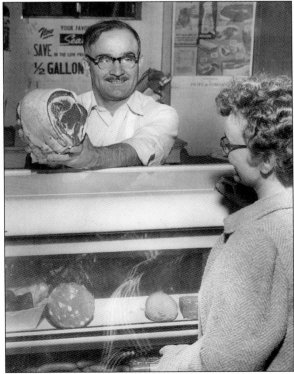

Dan Savocchio shows a well-marbled rib roast to a happy customer at his Brown Avenue Food Market around 1946. Dan was well known in the Italian community and St. Paul's Church. He worked at many festivals and communion breakfasts. In addition to being a founding member of the Home Owned Food Stores Association, he was also a founder of the Giuseppe Mazzini Civic Association and of the Rocca Pia Society. (Joyce Savocchio.)

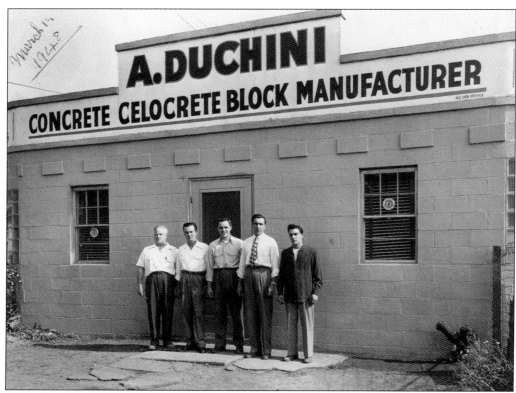

In the early 1920s, Avellino Duchini, a skilled mason, arrived in Erie from Italy. While working for a contractor, Avellino made pre-cast laundry tubs and concrete vases with the help of his wife, Ida Gianoni. In 1932, he started his own business making cement blocks for commercial and residential buildings. Shown from left to right are Avellino Duchini, his son, Adelmo, and brothers-in-law Guido, Vincent, and Albert Gianoni. (A. Duchini Company.)

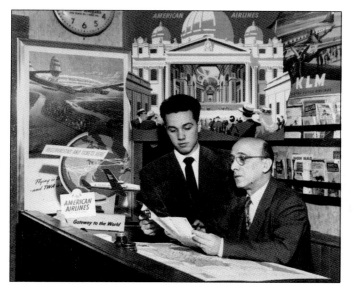

The Cappabianca Travel Agency, at 420 West Eighteenth Street, met the needs of Italian immigrants who wished to return to Italy to visit relatives. It was founded by Giovanni Cappabianca in the 1940s. He is shown here with his son, Pasqualino (Patrick), who expanded the agency after his father's death. His daughters, Lisa and Carla, continue the family tradition with offices on State Street. Giovanni also started the first broadcast of the "Italian Hour" on a local Erie radio station. (Patrick Cappabianca.)

This picture was taken at the completion of Norma Palandro Webb's probationary period as a student nurse at St. Vincent Hospital School of Nursing in 1944. Norma graduated in 1946 as a registered nurse. She had a successful career in the urology department there, as well as a period of time at Shadyside Hospital in Pittsburg. She retired from St. Vincent Hospital in 1970. (Norma Palandro Webb.)

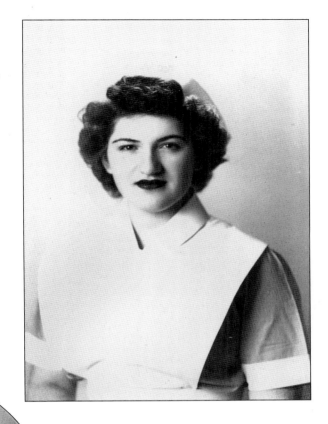

Arturo Oligeri was appointed to the City of Erie Police Force in 1922, one of the first young Italians to be so appointed. He was born in Tuscany, Italy. He served in the U.S. Army during World War I. As a policeman, he also acted as a counselor to troubled Italian families. (Gerri Oligeri.)

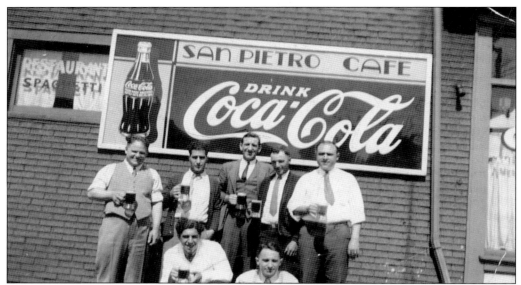

Dominic SanPietro emigrated from Rome in 1913 at the age of six. His wife, Carmella Rugare, was born in Calabria. Dominic owned the SanPietro Café at 1126 Buffalo Road, which stands today as the Knotty Pine Tavern. Dominic's daughter, Vera, married Andrew DeDionisio, who later operated Dante's Café. (Diane DeDionisio Davies.)

Many celebrities appeared in Erie. Pictured here are the famous Andrew Sisters at the armory on East Sixth Street. The orchestra leader, also a talented violinist, was Amerigo Meola, son of Domenic and Tomasina Quarino Meola, who came to America in the early 1900s from Avellino. The orchestra had several talented first-generation Italian American musicians from Erie's Little Italy. (Evelyn Grack.)

Angela Montagna Quick Eddinger is shown here in 1952 as "Linda Page," her radio personality at WIKK in Erie. She interviewed guests such as comedian Dom De Luis and boxing promoter Don King. She also offered recipes, household tips, and so forth. She later worked at several local television stations doing commercials for various supermarkets. Angela's parents were Joseph and Concetta Mennetti Montagna, emigrants from Calabria, Italy. (Debra Lewis.)

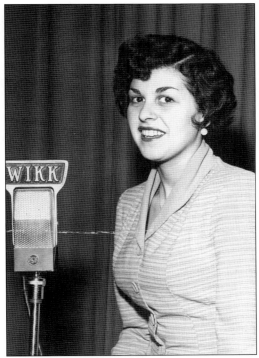

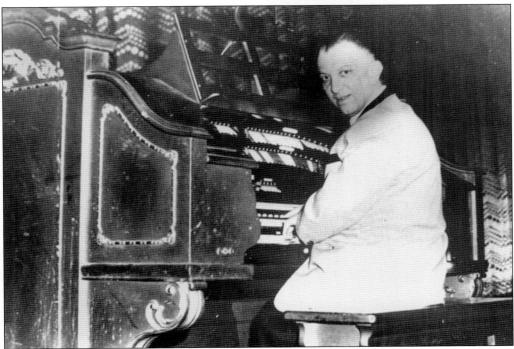

Pictured here is Anthony Conti, a talented organist, playing the mighty Wurlitzer at the beautiful Warner Theater. He played for many stage performances and also entertained the children at Saturday morning cartoons and movies. (Erma Lombardozzi/Paul Morabito Collection.)

Cianfoni's Band

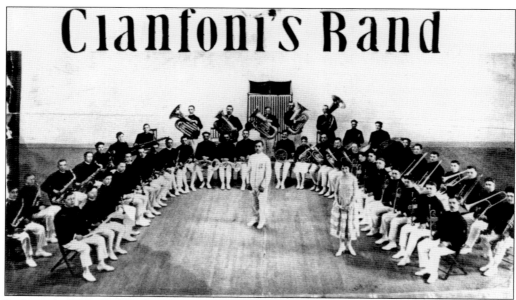

In the early 1920s, Prof. D. Cianfoni arrived in Erie to organize a concert band. Most of the members were talented Italian immigrants. They are shown here performing from the stage of Academy High School. The female vocalist is unidentified. This organization of fine musicians was much sought after for concerts all over the city of Erie. (Erma Lombardozzi/Paul Morabito Collection.)

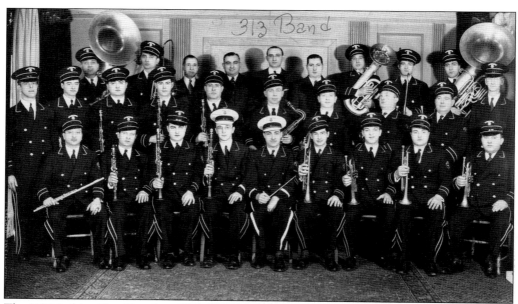

The 313 Machine Gun Battalion Club, located on Peach Street near Twentieth Street, had its own band in the early 1940s and 1950s. Anthony Savelli, shown fifth from the left, was the conductor. The Italian community had many talented musicians. Although specific individuals could not be identified, names that were recalled included Joe Amoroso, Andrea Sforza, John Gianamore, Joe Marinelli, and Victor Savelli, the conductor's brother. (Gerri Oligeri.)

Anthony Savelli was born in Sezze, Italy. He came to America in 1911. He played the clarinet and the saxophone and conducted the concert band that played every Sunday at Glenwood Kiwanis Shell for many years beginning in 1939. Savelli was band master at Cathedral Preparatory School for 26 years and had a successful career playing professionally during the 1940s and 1950s. He and his wife, Veda Tomassi, had three children, Geraldine, Kenneth, and Vincent. (Gerri Oligeri.)

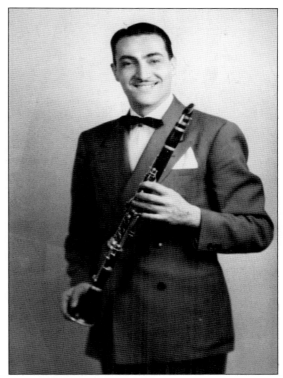

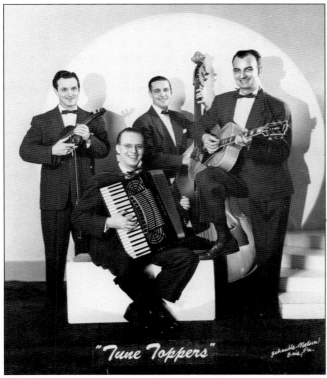

The Tune Toppers were four talented local musicians who played at many local clubs in the 1940s and 1950s. When television came along in the 1950s, they also appeared on the Firch Baking Company Variety Show on local television stations. Standing from left to right are Jimmy and John Manucci and Dick Honard. The accordion player, seated, is Dick Hunter. (Audrey Walker.)

Mary Fabrizio McCarthy established Frontier Pharmacy in 1958. She was the first Erie woman to own her own pharmacy. Mary's parents, Amico (Mike) and Felicita Danese Fabrizio, emigrated from Montenero in 1913. While working at Continental Rubber Works, Amico lost a leg. A fellow paesan in the hospital offered to teach him to make shoes. Amico opened his first shop on Scott Street. Today the Frontier Pharmacy is owned by Tom Toale, Mary's nephew. (Mary C. Fabrizio McCarthy.)

Michael Santomenna was born in San Fele in 1890 and emigrated in 1905. After attending pharmacy school at Brooklyn University, he settled in Erie and established Colonial Drug Store at 524 West Eighteenth Street. He married Mary Agresti. They had four children—Gloria, Olga, Anita, and Michael. Adolph Agresti (left) also became a pharmacist, as did the two young men behind the soda fountain, Perry Roseto and Eddie Pasqualicchio. Son Michael Santomenna is a retired surgeon. (Dr. Michael Santomenna.)

Dr. Samuel L. Scibetta was five years old when his family came from Italy in 1898. He graduated from the University of Buffalo Medical School. After medical service in World War I, he opened an office in Erie. He was on the staff of Hamot and St. Vincent Hospitals for 30 years. He married Angeline Palmisano. Their sons, Peter, Richard, and Louis, were doctors. (Dr. Peter Scibetta.)

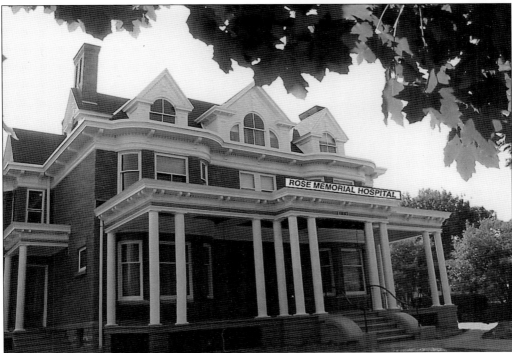

Many early immigrants feared being hospitalized. Dr. Samuel L. Scibetta saw a need in the Italian community and founded a clinic and hospital in 1926. A former mansion at 139 West Twenty-first Street was fitted with 15 beds. It was called Rose Memorial Hospital in honor of his mother. The hospital closed in 1936. Drs. Scibetta and Frank Trippe were the first Italian doctors to practice in Erie. (Dr. Peter Scibetta.)

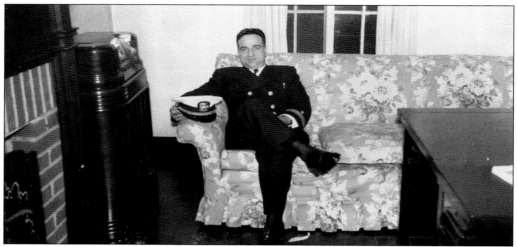

Dr. Michael J. Pistorio interrupted his medical practice at 1624 Myrtle Street to enlist in the U.S. Navy in 1942. He is shown here on military leave. Dr. Pictorio attended Erie schools and then graduated from Loyola School of Medicine, Chicago, Illinois, in 1929. His parents, Domenic and Margaret Corso, immigrated to the United States from Imersi, Sicily, in 1896. They had a produce business in the old central market. Michael was one of eight children. (Mike Pistorio.)

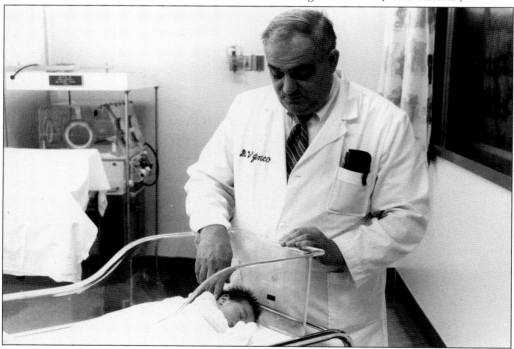

Dr. Vincent L. Jenco had a long career as a gynecologist and obstetrician, shown here with one of the thousands of babies he delivered. After graduating from Cathedral Prep School, he received a bachelor of science degree from Gannon College and attended Kansas City College of Osteopathy in 1958. After retiring, he saw a great need to give medical aid to the poor and uninsured. He established St. Paul's Free Clinic at 1608 Walnut Street in 1993. His parents were Philomena Di Nicola and Anthony Jenco. (Ann Mazzeo.)

Three
EDUCATION, YOUTH, AND SPORTS

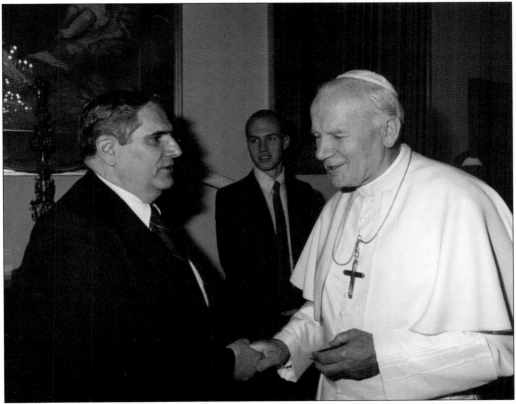

Representing the Fellowship of Catholic Scholars, Dr. Joseph Scottino, left, and three students from Gannon University met with Pope John Paul II in Rome. The visit included a private mass and audience with the pope. They were also the guests of the U.S. ambassador to Vatican City, Thomas Melady. The group celebrated Thanksgiving Day with seminarians at the North American College in Rome. (Mary Lou Scottino.)

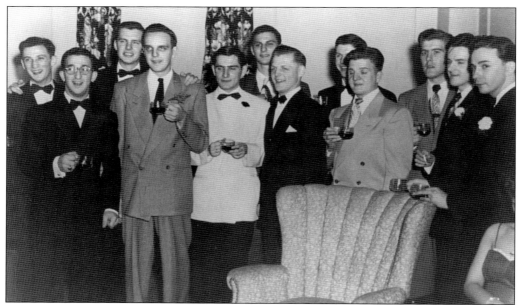

This photograph was taken at the old Lawrence Hotel about 1949 in downtown Erie. It shows a group of Gannon College students (now Gannon University), including Joseph Scottino, shown in the white jacket, enjoying some refreshments before a formal dance. College dances such as these were usually held either at the school's auditorium or at Waldameer Park. Dr. Joseph Scottino went on to become the president of Gannon University in 1977. (Mary Lou Scottino.)

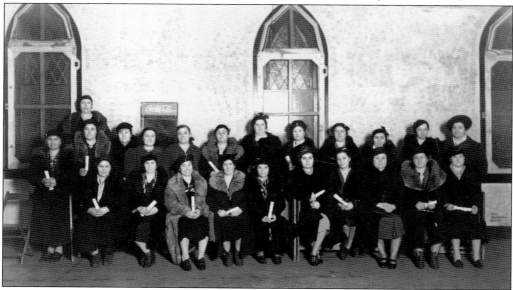

Rose Vetter, extreme right in second row, is shown with one of several naturalization classes she taught in the 1930s. It was difficult for Italian immigrants who spoke little English to learn all about American government. Vetter was patient, thorough, and since all of the immigrants were anxious to become American citizens, they flocked to her classes and passed with flying colors. Identified are Bianchina Codespoti, seventh from the left in the second row, and Philomena Bianco, ninth from left in the second row. (Agnes Ruscitto/Charlene Sisson.)

Pictured here is a naturalization class in 1926 at the YMCA. Most of the men are Italian immigrants, including names such as Arduini, Malizia, Daniele, Chemi, and Salvatore Vitelli, who is the first man on the left. The three women instructors are unidentified. Immigrants studied hard and were proud when they received their American citizenship papers. (Rena Wierbinski.)

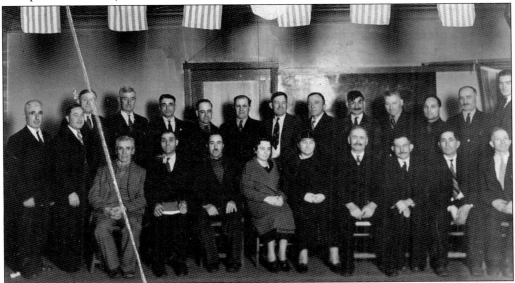

Pictured here is a naturalization class from the Liberty Club, originally in the 1200 block of East Twenty-sixth Street. Paesani from Abruzzi socialized at this club. Shown from left to right are (standing) unidentified, Louis Matz, Tom Toscan, David Yezzi, Phillip Vanucci, Mr. Lupo, Mr. Frazini, Antonio Sciamanda, unidentified, Domenic Gianoni, Domenic Barbell, unidentified, Pasquale Ferretti, and unidentified; (seated) Fundangelo Ferretti, Luigi Cichetti, unidentified, Florence Tullio, Julia Faraone, Emidio Yezzi, Mr. Di Luzio, Mr. Pate, and January Sansone. (Al Yezzi/Jim Gianoni.)

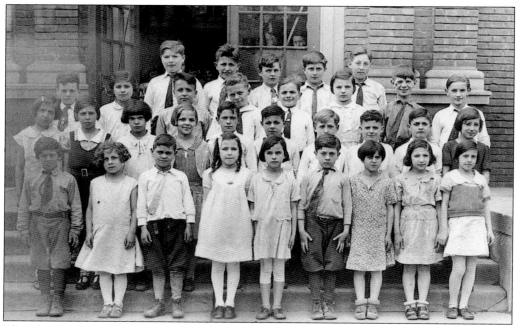

This charming picture from Columbus School was taken around 1934. Some of the names are (first row) Frank Agnello, Gina Vitelli, and Josephine Palermo; (second row) Rose Bizarro, Dora DePalma, Gino DeAurora, and Cosimo DiCarlo; (third row) Anne Ciotti, Fiorenzo Ciotti, and Carl Banducci; (forth row) Sam Marucci and Louis Cutri. (Vince Palermo.)

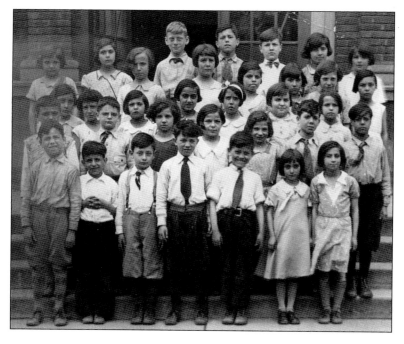

Here is another typical group of youngsters, mostly children of Italian immigrants, at Columbus School around 1930. (Courtesy Erma Lombardozzi/Paul Morabito Collection.)

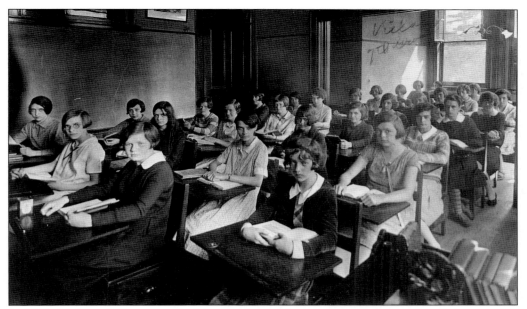

In 1920, Anthony Pallotto sent for his wife, Annunziata, and daughter, Angelina (who was nine years old), from Montenero. Anthony wanted Angelina to learn English as soon as possible, so he enrolled her at Villa Maria Elementary School, where she was placed in eighth grade in this 1921 photograph. Angelina is fourth from the left in the first row. Their first home was at 1819 Plum Street. (Nance Hoffman.)

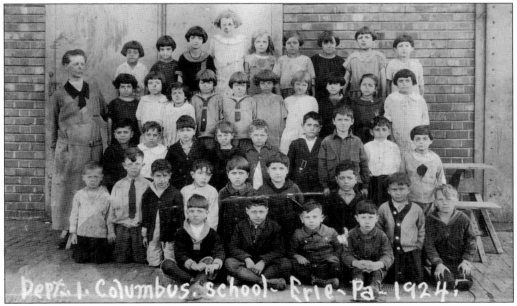

Columbus School, at Sixteenth and Poplar Streets, was in the heart of Little Italy. Italian immigrants were proud of their children's studies. They took advantage of the books the children brought home, learning English as the children advanced in their studies. Pictured here is a first-grade class of 1924. The contributor recognized his brother, Angelo Ruscitto, seated fourth from the left. (Joseph Ruscitto.)

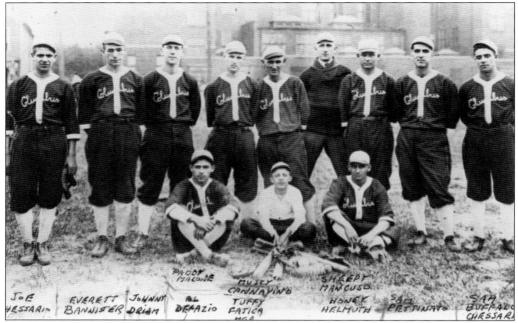

The young men in this picture had discovered America's favorite pastime, baseball. Shown here is the Columbus Athletic Club. From left to right are (first row) "Paddy" Malone, "Musty" Cannavino, and "Sheepy" Mancuso; (second row) Joe Chessario, Everett Bannister, John Driam, Al DeFazio, "Tuffy" Fatica (manager), Honey Helmuth, Sam Pettinato, Sam "Buffalo" Chessario, and Mike "Cacchy" DeFazio. Colorful nicknames were common among the young men of the neighborhood. (John Fatica.)

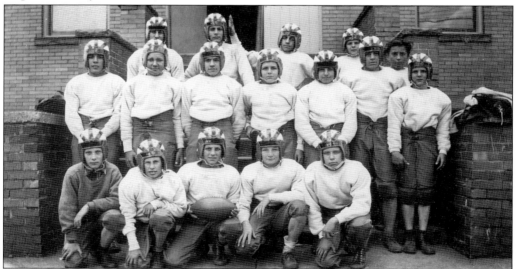

Standing in front of the Liberty Club is the East Twenty-sixth Street football team around 1935. A game with a Little Italy football team was a big rivalry. Leagues were loosely organized and usually sponsored by neighborhood Italian clubs. Although not identified individually, the contributor recalls names such as De Santi, Ferretti, Bernardini, Buffalari, and Gianoni, all from the upper east side of Erie. (Jim Gianoni.)

Pictured here is the 1927 Roosevelt Junior High School Track team. They placed second in the city. Shown from left to right are (first row) J. Freebourne, G. De Marco, Theo Rosenthal, D. Aditori, D. Serafene, and N. Del Porto; (second row) Sam Colao, C. Bauder, C. De Nick, A. Smith, G. Miano, and unidentified; (third row) E. Sayer (coach), E. Presogna, E. Lintelman, B. Agresti, H. Mehl, E. Entley, and T. Garpetti (manager). (Erma Lombardozzi/Paul Morabito Collection.)

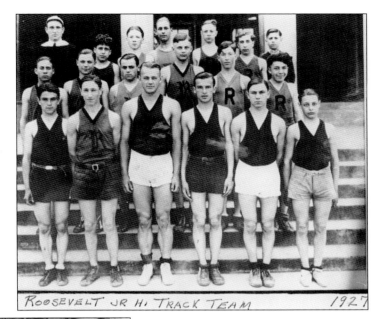

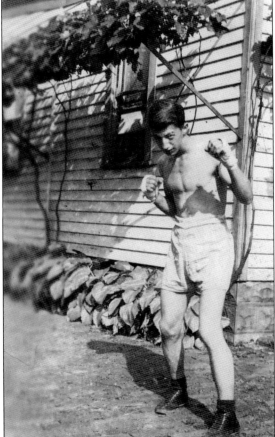

In 1938, fifteen-year-old Mario S. Bagnoni won the Golden Gloves award in boxing. He was the son of Oreste and Doride Michele. Mario was two years old when he emigrated with them from northern Italy. After serving in the U.S. Coast Guard in World War II, Mario was a professional musician before becoming a policeman for the City of Erie. He retired as deputy police chief. He served as an Erie councilman for 32 years. (Rita Chizmadia.)

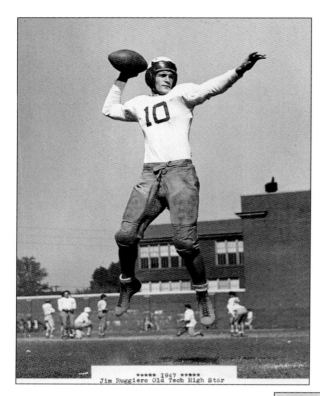

Many young Italian American boys attended Old Technical High School to learn a trade. Several also became great athletes. Pictured here is football star Jim Ruggiero in 1947. (Erma Lombardozzi/Paul Morabito Collection.)

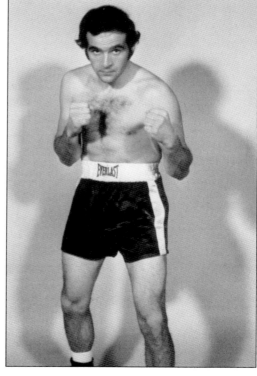

Striking a boxing pose is Lou Bizzarro at the age of 18. He is the son of the late Angelo Bizzarro and Elizabeth Mezzacappo, who emigrated from Marchenese, Province Di Caserta, in the late 1890s. Lou is very active in mentoring young boxers as they train for their careers in the ring. (Lou Bizzarro.)

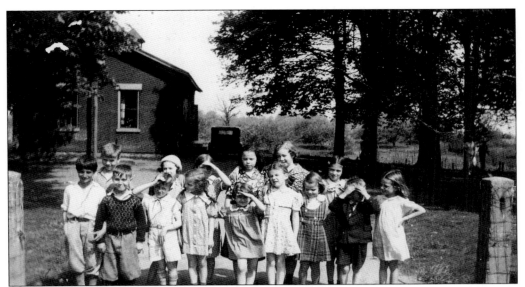

Standing in front of a typical rural school house on U.S. Route 20 in North East are the classmates of Anthony Mobilia (seventh from left in first row). The photograph was taken around the late 1930s. Anthony's parents were Carmelo and Fortunata Mobilia, emigrants from Sicily. The schoolhouse is a private home today. (Nancey Hersch.)

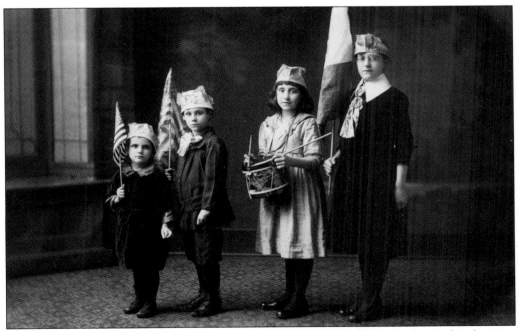

Shown here are the children of Rosario and Concetta De Francisco honoring their Italian heritage and celebrating being young Americans. At left are Helen and Dominic waving American flags. Lucy is the "spirit of 76," and Josephine is holding the Italian flag. Their parents emigrated from Bagheria, Sicily. The occasion was an Italian American festivity around the early 1920s. (Julie Shadeck.)

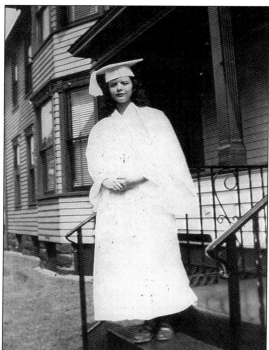

Dolores (Pruvedenti) Estes stands in front of the family home at 1701 Cherry Street following graduation in 1948 from Strong Vincent High School. Michael, Dolores's father, emigrated from Matrice, Italy. The family of her mother, Pasqualina DiNunzio Pruvedenti, was from a small town in Abruzzi, Italy. Dolores and her husband, Keith, now reside in Clearwater, Florida. (Dolores Estes.)

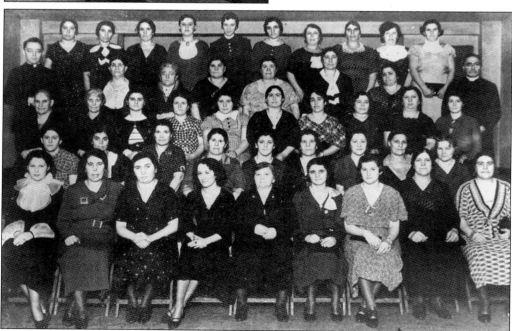

In 1934, two energetic sisters, Rachel Cacchione and Sue Phillips, conceived the idea of banding together all the women whose roots were in Valcocchiara, Montenero. Their mission was to help the church and to provide mutual aid for members. Pictured is La Societa Nationale di Montenero. The descendants of this group still meet on a monthly basis to carry on the traditions established 80 years ago. (Erma Lombardozzi/Paul Morabito Collection.)

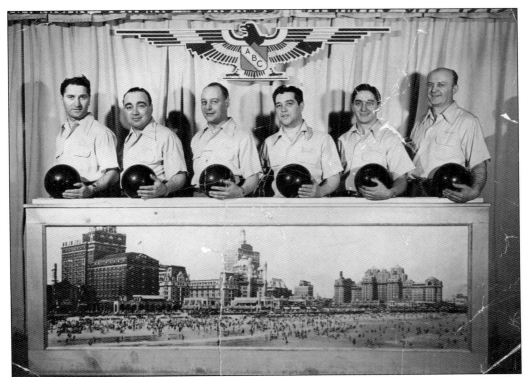

Bowling was a popular sport among the young adults of the Italian neighborhoods. In Little Italy, bowling alleys were located at the Nuova Aurora Club and the Calabrese Club, both on Sixteenth and Walnut Streets. Here is the champion bowling team from Erie in Atlantic City, New Jersey. From left to right are Archie Tonti, Joe "Socket" Soccoccio, Nell Del Porto, Tom Iacobozzi, Anthony "Cherries" Bucceri, and John Little. (Lena Soccoccio.)

Many young Italian American women enjoyed bowling as a form of recreation. They took pride in winning several state championships. Here is the 1951 team from the Calabrese Club at Allentown. Shown from left to right are Jeanette McLellan, Lena Soccoccio, Helen Shioleno, Martha Ferrare, and Margaret Mantoan Romeo. (Lena Soccoccio.)

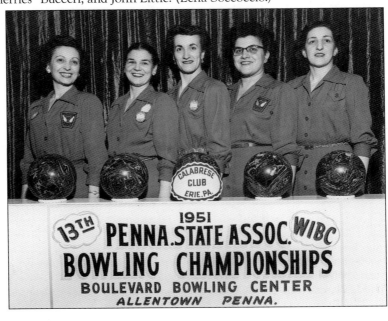

Mary Porreco, pictured at age 17, was one of the first Italian women to graduate from Edinboro Normal School in 1924. She is fondly remembered by many Italian students at Columbus Elementary School during the 1920s and 1930s as she patiently helped them perfect their English language skills and assisted parents as they learned about various school functions. (Edinboro University Porreco Campus.)

Shown here is Mary Porreco as she exits a school. Linda Rys, a former student, recalls making papier-mâché heads for puppets in Porreco's fourth grade class and putting on a puppet show with costumes made by the mothers. At a 45-year class reunion, a classmate brought her puppet to the reunion. Porreco still lives on in the memories of students whose lives she touched. (Lou Porreco.)

Four
MILITARY

Pictured here are Arturo Oligeri and his wife, Elisa Pietrasanta, both of whom were originally from Tuscany, Italy. After serving in the U.S. Army in World War I, he returned to Erie and was appointed to the City of Erie Police Force. (Gerri Oligeri.)

Nick Corso grew up on Fifteenth and Chestnut Streets. He served on the front line in France during World War I and was wounded. Later in life, he became a well-known Erie bowler with two perfect 300 scores. He was of Sicilian heritage. (Antonina Siggia.)

In 1916, Salvatore Vitelli was in the Italian army fighting in Libya. He recalled that his regiment was not receiving food and supplies, and many were dying from wounds and malaria. After the war, Salvatore returned to his home in Sezze, Italy. He married Rosa De Angelis, the love of his life. They came to America in 1920. They settled in Little Italy and had seven children. (Rena Wierbinski.)

Show in this photograph is Dominic (Daniel) Carneval as a U.S. Army private in World War I. When the United States entered World War I, Dominic was drafted into the army and served in the European theater of combat. He was injured and became a prisoner of war in France. After the war, he received two Purple Hearts for the injuries he received in combat and also for his POW status. (John Carneval.)

Giovanni (John) Guido, an early resident of Erie's Italian community, was a private in the U.S. Army during World War I. Many immigrants were granted American citizenship after serving in that war. A portrait of Giovanni's wife, Maria, and their children can be seen on page 17. John and Maria both emigrated from Amantea, Province Di Cosenza. (Ann Guido.)

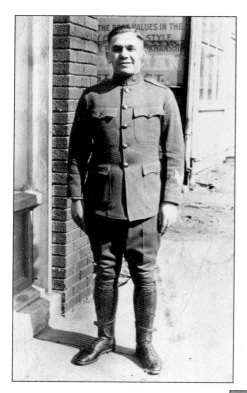

Jess Juliante, son of Dominic and Nicoletta Juliante, emigrants from Pennapiedemonte in 1885, enlisted in the army in World War I and was with the ordinance corps. He was discharged in 1919 with the rank of ordinance sergeant. In the fall of that year, he entered law school at the University of Pennsylvania, and he graduated in 1922. (Frances Quadri.)

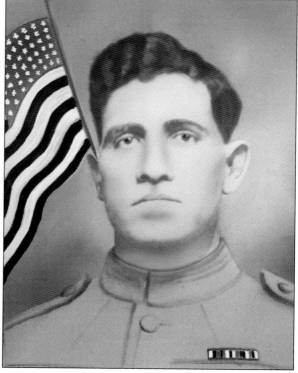

Michael Codespoti immigrated to the United States from Samo, Reggio, Calabria, Italy. Like many immigrants, Michael served in the U.S. Army during World War I. He later returned to Italy, married Antonia Bonfa of Samo, came back to America, and worked on the railroad. Ironically his brother-in-law was an enlisted man in the Italian army during World War I. (Agnes Ruscitto.)

Lou Tullio, a navy man, is pictured here with his parents, Anthony and Ercilia Tullio, during World War II. Anthony and Ercilia emigrated from Villa Corso and settled at 930 East Thirty-eighth Street. A graduate of Cathedral Preparatory High School, Lou attended Holy Cross on a football scholarship. Lou coached the football team at Gannon after World War II and became the first Italian American mayor of the city of Erie. The family owned Tullio Construction Company. (June Pintea/John Tullio.)

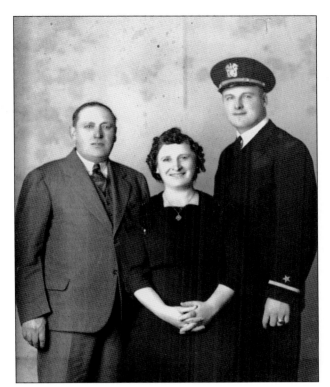

Italo S. Cappabianca was the son of Giovanni Cappabianca (Italian royal vice consul) and Luigina Barboni. He served in the U.S. Army in the Korean War and was stationed in Germany, entering politics after the war. He was elected to the Pennsylvania House of Representatives, Second District, and served for 22 years. (Lisa Cappabianca.)

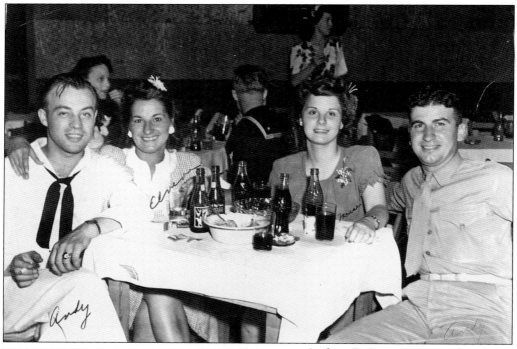

Andrew DeDionisio was stationed in Norfolk, Virginia, in the U.S. Marine Corps. Here he is with his new bride, Vera SanPietro, and unidentified friends on their honeymoon in 1943. (Diane DeDionisio Davies.)

Shown here in 1945 during World War II relaxing during a break in duties at Barkdale Field, Camp Claiborne, Louisiana, are, from left to right, buddies "Ian" Santangelo, John Fatica, and Tom Yacobozzi. (John Fatica.)

Show on the far left is Supply Sgt. Victor Savelli with his buddies in Munich, Germany, during World War II in 1944. He and his buddies are enjoying a German beer. They were part of General Patton's Third Army. Many young first-generation Italian Americans, despite the dangers of war, were anxious to serve their country and were among the first to enlist. (Victor Savelli.)

Joseph J. Borgia served in World War II with a combat unit and was a survivor of the Battle of the Bulge. Joe came to America at seven months of age with his parents, Santo and Assunta Cesario Borgia, from San Lucido, Calabria, Italy. Joe and his wife, Rita Hoh, had seven children. Joe was active in Erie city politics. He was a city councilman and a human relations commissioner for Pennsylvania for nine years. (Joe Borgia.)

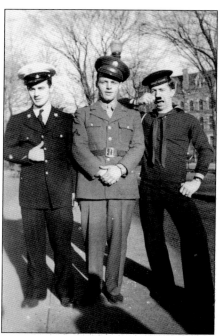

Posing at Perry Square in Erie during military leave in World War II are, from left to right, Walter Bagnoni, Bruno Ambrose, and Mario Bagnoni, doing an imitation of Adolph Hitler with his mustache comb. (Audrey Walker.)

During World War II, Lawrence Adiutori (left) served in the U.S. Army for four years. He was stationed in the South Pacific. On returning home after honorable discharge, he helped his father in the grocery business in a store at Sixteenth and Chestnut Streets and later opened a store at Seventeenth and Sassafras Streets. Larry II, Larry III, and young nephew Jamie, are fourth and fifth generations in the grocery business. The soldier on the right is unidentified. (Larry Adiutori.)

Sgt. Vincent R. "Buddy" Palermo served in the U.S. Army Air Forces. This photograph was taken in March 1943. He was the son of Salvatore and Rose Palermo, emigrants from Sicily. (Vincent Palermo.)

Florindo "Shorty" Ciotti served in World War II as a private first class in the U.S. Army in the Philippines. His parents were Giovana Letterio and Domenico Ciotti from Rocca Pia, Italy. Dominico Ciotti was killed in an accident at National Erie Forge in 1924. Two other sons, Domenic and Frank, were killed on D-Day in Normandy in 1944. (Joanne Werth.)

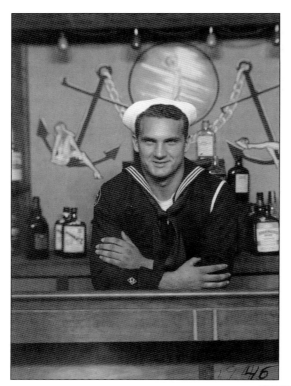

Paul Morabito served in the navy as a Seabee in the Pacific theater. Prior to being drafted, Paul was offered football scholarships at four major universities. Later he worked for the Erie School District as an electrician for 35 years. His hobbies were winemaking and researching Erie and Little Italy history. He and his wife, Irma, had four children. (Erma Lombardozzi/Paul Marabito Collection.)

Mario Bagnoni served in the U.S. Coast Guard during World War II. He entered politics, serving as a councilman for 32 years. He and his wife, Jane (King), had six children. Mario always spoke out for the "little man" and senior citizens. (Rita Chizmadia.)

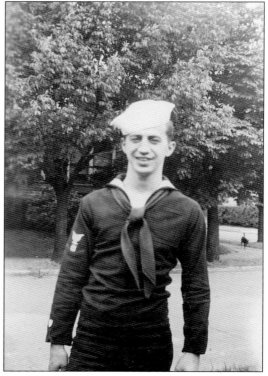

John Orlando served as a fighter pilot during World War II in the South Pacific. He is seen here in his P-47 Thunderbolt, which he flew when he was stationed in the Philippine Islands. First Lieutenant Orlando was awarded the Army Air Corps Air Medal for distinguishing himself by meritorious achievement while participating in aerial combat with the enemy. After the war, he established the John R. Orlando Funeral Home in 1949. (James Orlando.)

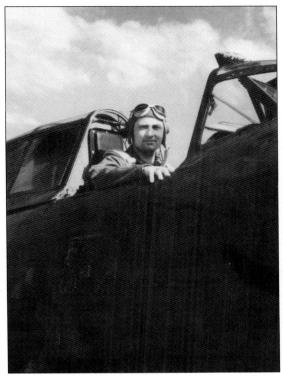

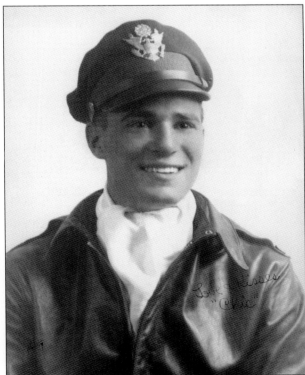

Giocondo ("Chic") Rufini, son of Germano and Augustina Rufini, was declared missing in action over the South China Sea in 1943. He was a navigator in the U.S. Army Air Force during World War II. At Strong Vincent High School, he excelled in basketball. He enlisted while attending Gannon College. His brothers, Pio and Foy, also served in the U.S. forces. (Lillian Minichelli.)

In June 1943, Dr. Michael Pistorio, right, was sent to Australia with the 7th Amphibious Fleet on the USS *Carter Hall*, an LSD. He saw service in initial assault invasions of the Admiralty Islands, Leyte, Luzon, and other Japanese-occupied islands in the Pacific. As a surgeon on several navy ships, he saw much action and many casualties. He was honorably discharged as lieutenant in October 1945. (Mike Pistorio.)

Tony Rigazzi is pictured here, home from the war, in the backyard of the family home at 2212 Plum Street with his mother, Marietta Rigazzi. Born in Rocca Pia, Tony came over in 1921 with his mother. Active in bowling and baseball, Tony worked at General Electric, where his father had also worked after arriving from Rocca Pia in 1915. (Gloria Rigazzi.)

Veterans Memorial

From December 8th, 1941 to April 9th, 1946 there were 723 men and women from Erie County (Pennsylvania) who died in the Second World War. At the present time a proposed memorial will be erected near the Erie Veterans Memorial Stadium at 26th and State Streets.

The Giuseppe Mazzini Civic Association urges all of our members, as well as the community at large, to support this worthy project.

Listed below are the names of those young Italian Americans who will be listed on the memorial along with their comrades of all national origins.

#	Name	Branch	Date	Location	#	Name	Branch	Date	Location
1.	Anthony J. Alo	Army	2/1/45	Germany	28.	Vincent C. Izzi	Navy	8/11/43	U.S.A.
2.	George M. Andre	Army	11/13/44	France	29.	Nick A. Jordano	Army	5/2/43	Pacific
3.	Joseph G. Barzano	Army	5/19/44	Germany	30.	Albert J. LoRusso	Army	8/1/45	Germany
4.	Michael P. Barzano	Army	12/24/44	Germany	31.	Carl L. Mango M.D.	Army	12/14/44	Japan
5.	Albert Bernadini	Army	1/14/45	Germany	32.	John J. Marabito	Army	4/29/44	Germany
6.	Donald G. Bevilacqua	Army	3/1/45	Adriatic	33.	Carl H. Menconi	Army	3/5/45	Germany
7.	Anthony J. Bongiorno	Army	6/11/45	India	34.	Horatio Migliore	Army	12/9/44	Unknown
8.	Richard L. Calabrese	Navy	3/??/45	S. Pacific	35.	George M. Minutillo	Army	1/14/45	Belgium
9.	John J. Chimenti	Army	12/??/44	France	36.	Anthony R. Natto	Army	12/9/44	Med.
10.	Alfred J. Cianflocco	Army	7/1/44	Burma	37.	Joseph L. Nicosia, Jr.	Army	8/9/44	France
11.	Vincent D. Ciotti	Army	7/16/44	France	38.	Louis Nopio	Army	1/25/45	France
12.	Samual Conti	Army	2/21/44	Italy	39.	Donalld R. Pallo	Army	9/17/44	Germany
13.	Vincent J. Cremia	Army	8/5/44	France	40.	Salvatore D. Pallotta	Army	4/3/45	Italy
14.	Nicholas A. DeBello	Army	6/2/44	Italy	41.	Louis F. Pascale	Navy	9/17/42	S. Pacific
15.	Frank G. DeDionisio	Army	10/13/44	Italy	42.	John Pitto	Navy	3/13/45	Iwo Jima
16.	Cosimos G. DeLaura	Army	7/13/44	France	43.	Frank J. Rigazzi	Army	7/11/44	France
17.	Eugene J. DeVoge	Army	5/5/45	Germany	44.	Giocondo A. Rufini	Army	11/16/44	China
18.	Albert J. DiLuzio	Army	11/18/44	Germany	45.	Joseph G. Salvage	Army	11/16/44	Germany
19.	Louis P. DiNicola	Army	10/6/44	Germany	46.	Angelo A. Scalise	Army	7/25/43	Solomon Isles
20.	Peter J. DiNitis	Army	11/26/43	Germany	47.	Eugene J. Seneta	Army	9/25/44	Italy
21.	Dominic A. DiTullio	Army	6/7/44	France	48.	Joseph J. Surrace	Army	11/17/44	France
22.	Leo J. Ferretti	Army	6/6/44	France	49.	Robert G. Surrena	Army	10/3/45	U.S.A.
23.	Mario J. Filigenzi	Army	5/13/45	England	50.	Eugene P. Tomassi	Navy	10/29/44	S. Pacific
24.	Emidio A. Gigliotti	Army	4/12/45	Luzon	51.	Lawrence S. Trippi	Army	7/8/44	France
25.	Dominick Guarino	Army	2/13/43	U.S.A.	52.	Donald P. Valentine	Army	5/23/44	Italy
26.	Alexander J. Guilianelli	Army	10/20/43	Holland	53.	Patsy Ventura	Army	11/29/44	Germany
27.	Joseph S. Izzi	Navy	6/8/44	S. Pacific					

We know that there were Italian American women (both native and immigrant) who had sons in the armed services from Erie County and who did not have an Italian surname. We regret that we were unable to honor them here.

The Giuseppe Mazzini Civic Association salutes all veterans who have served their country in times of armed conflict, and honor our fallen friends from Erie's Italian American community - may they rest in peace! "God Bless America!"

The Committee

This is a partial listing of the Italian American men who died in World War II, compiled by the Giuseppe Mazzini Civic Association. (Norma Palandro Webb.)

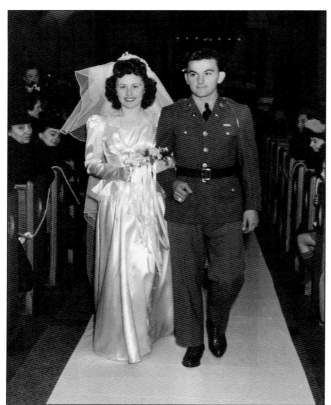

While on military leave, Sgt. Eugene Rocco married Antoinette Iacovetta at St. Paul's Church in 1942. Antoinette came to America with her parents as a youngster. Eugene's parents, Joseph and Susan DeFonzo, came from Rocca Pia, Italy. After an honorable discharge, Eugene worked and retired from Marx Toys Company. This wedding was the first of many military weddings performed during World War II at St. Paul's Church. (Caroline Vendetti.)

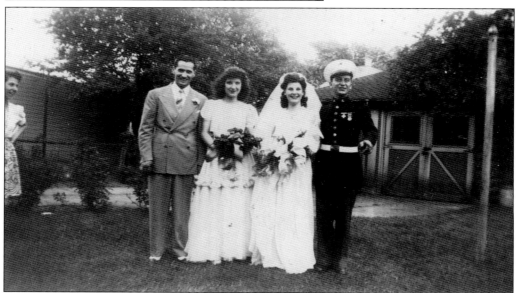

Andrew DeDionisio and Vera San Pietro (on the right) were married at St. Patrick's Church in 1943 and had their reception at the East Twenty-third Street home of Vera's parents, Carmela Rugare and Dominic SanPietro, emigrants from Calabria and southern Italy. Also in this picture are Don Rogala and Virginia DeDionisio, best man and bridesmaid. (Diane DeDionisio Davies.)

Five
Church and Religion

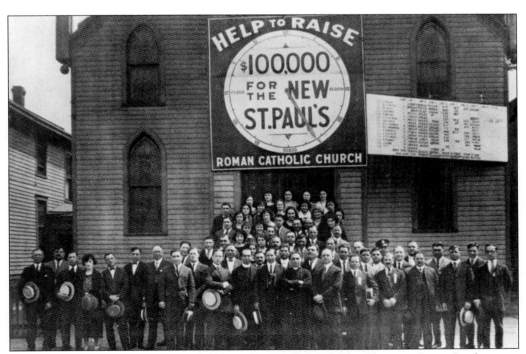

St. Paul's Church, a wooden frame building that was formerly the Chestnut Street Presbyterian Church, was located on Walnut Street since 1893. In 1928, parishioners gathered in front of the church to start a campaign to raise funds for a new structure in the Romanesque style. The new building was dedicated on March 17, 1935. (Erma Lombardozzi/Paul Morabito Collection.)

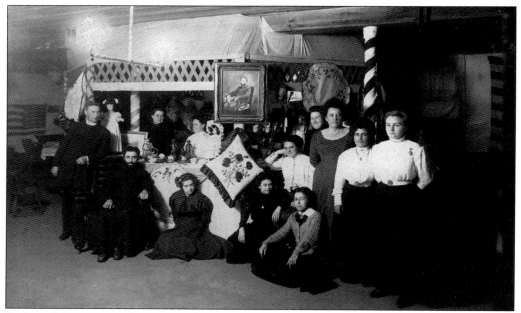

Fr. Louis Marino, seated, is surrounded by a women's group at St. Paul's Church in the early part of the 1900s. Bazaars and festivals had already begun to be important fund-raisers for the needs of the church. (St. Paul's Church Archives.)

Beloved Fr. Louis A. Marino, longtime pastor of St. Paul's Church, was a casual man of simple tastes. He could be seen quite often around the rectory, which was located around the corner from the church on West Sixteenth Street. He was usually in his shirt sleeves with his ever-present suspenders, greeting passersby. (Dora Mazzeo.)

Pasquale Pallotto and Constantina Orlando are shown here on their wedding day in Montenero, Valcocchiara, Italy, in 1922, before emigrating. Pasquale worked at Griffin Manufacturing and at Louis Marx Toy Company. They had three children: George, Mary, and Nicolina (Nikki). (Nikki Baker.)

Anthony C. DiPlacido is shown here with his pretty bride, Jeannette DeGeorge, in 1913. Anthony emigrated from Pennapiedemonte. He worked as a foreman at American Cyanide, located between Seventeenth, Eighteenth, and Cranberry Streets. Pictured with the newlyweds are the bride's parents, Anthony and Florence DeGeorge. (Jeannette Spinelli.)

Giuseppe Catania and Maria Millemaci were married in 1922 at St. Paul's Church. Giuseppe emigrated from Maro, Montalbano, Sicily, in 1906. He settled in Erie in 1916. They had four sons: Joseph, James, Carmen, and Charles. (Charles Catania.)

Pictured here in 1920 are Italia Arcoletti and Luigi Malizia, emigrants from Rome, Italy. They married in Erie at St. Paul's Church, lived at 423 West Seventeenth Street, and raised four children, including their niece, Gloria, whose mother died in childbirth. (Gloria Rigazzi/George and Jean DePalma.)

Pictured here on their wedding day are Leo and Teresa Frizzi Iavarone around 1920. Leo emigrated from Bari and worked at Urick Foundry on Cherry Street to earn enough money to send for Teresa. They were married at St. Paul's Church and lived at 445 Huron Street. They raised three boys, Donato, Nicola, and Joseph. Leo retired as a janitor from St. Paul's Parochial School. Teresa was a housekeeper for St. Paul's Church rectory. (Jackie Iavarone.)

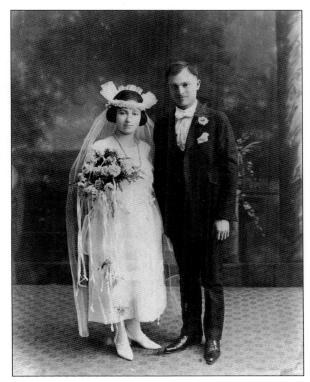

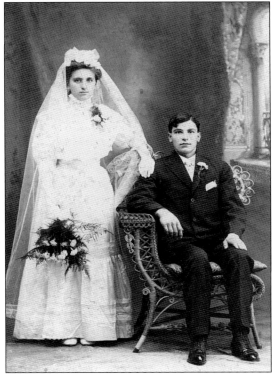

Pasquale D'Aurora came to America from Rocca Pia, Italy, at the age of 19 in 1906. He started a roofing business with his brother, Domenic, at West Eighteenth and Cherry Streets. He married Concetta Amatangelo, also from Rocca Pia, in 1908 at the original St. Paul's Church on Walnut Street. The bride was 15 years old. They raised 11 children. (Fran Konkol.)

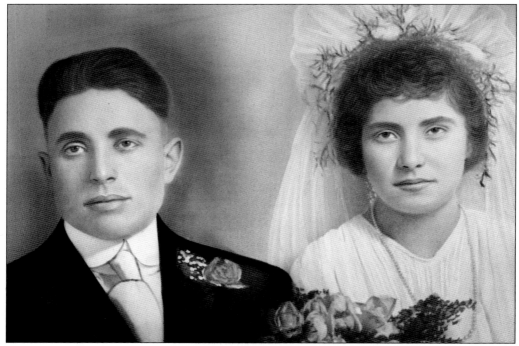

In 1920, Dominic (Daniel) Carneval married Antoinette (Anna) Pate, age 16, at St. Paul's Church. Dominic, born in 1896, emigrated in 1916 from Pico, and Antoinette, born in 1904, came in 1919 from Cosenza. Dominic met Antoinette through a paesan, John Pate, Antoinette's father. Both men worked digging ditches around Holland Street. The couple settled near Holland Street. Dominic worked as a machine operator at Perry Iron Works and then at Penelec for 45 years. (John Carneval.)

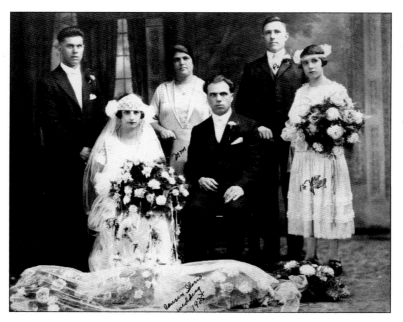

In 1925, Illario Yacobozzi and his wife, Carmelina, are shown on their wedding day with aunt Annunziata and uncle Antonio Pallotto and their daughter, 15-year-old Angeline. The gentleman on the left is unidentified. These paesani were natives of Montenero, Italy. Illario later introduced young Angeline to her future husband, Amadeo Pede. (Nance Hoffman.)

From left to right, newlyweds Rose and Charles Alfieri can be seen on their wedding day with best friends and next-door neighbors Laura and Lawrence Fatica, who were their attendants, around 1917. (John Fatica.)

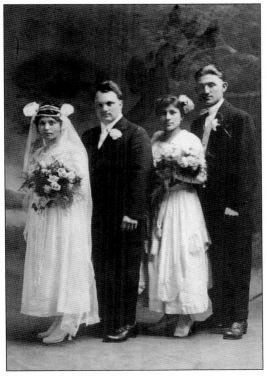

Pictured here are Brigida Di Santo Dascanio (seated) and Joseph Dascanio on their wedding day at St. Paul's Church in 1919. They were married by Fr. Louis Marino. Pictured standing behind the bride, from left to right, are Peter Di Santo, best man, Joseph Dascanio, and maid of honor Liz (Alesina) Di Santo Vali. Brigida was 17 years old when she was married. They had four children: Dominick (Dan), Bernard (Babe), Rose Marie, and Joseph. (Patty McMahon.)

Frank Berarducci, a native of Rocca Pia, Italy, is shown here with his bride, Lillie Leone, on their wedding day in West Newton, Pennsylvania, on June 2, 1930. They moved to Erie shortly thereafter. Frank was co-owner of Berarducci and Clemente Grocery store at 1618 Walnut Street. The couple had four daughters—Antoinette Mucci, Julia Gorbatoff, Placida "Patty" Cappabianca, and Norma Heise—and a son, Julian. (Antoinette Mucci.)

Pictured here on their wedding day are Dan Savocchio and Esther Leone. Dan and his brother-in-law, Frank Berarducci, had a grocery store on Brown Avenue. Dan's wife, Esther, manned the cash register. Their only daughter, Joyce, helped out after school. Joyce was elected mayor of the city of Erie for two terms—the first woman and second Italian American, following Lou Tullio, to be elected to the post. (Joyce Savocchio.)

Lucia Mariani and Carlo Yezzi were married at St. Paul's Church in 1924. They made their home at 1222 East Twenty-sixth Street. Several paesani from Abruzzi, Italy, also settled in this area of southeast Erie. (Al Yezzi.)

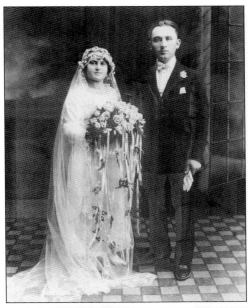

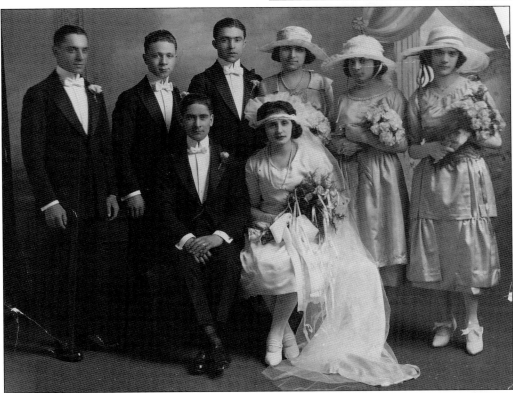

Fred and Dora Orsey on their wedding day are surrounded by their bridesmaids and groomsmen. Dora was the daughter of Gioachino and Louisa Del Porto, emigrants from Tuscany. They lived on Walnut Street, and Mr. Del Porto sold fruits and vegetables from a push cart. He and his sons later opened Del Porto Fruits and Produce store at Eighteenth and Sassafras Streets. (Ann Mazzeo.)

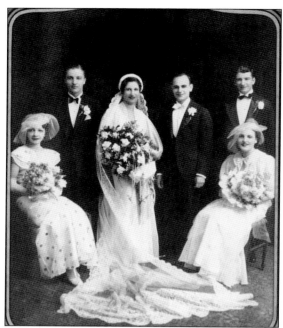

On September 2, 1935, Ralph Battaglia married Nancy DiDionisio at St. Paul's Church. Shown from left to right are Christina Pape, Adolph Agresti, Nancy, Ralph, Eugene DiDionisio, and Stella Battaglia. Ralph was a salesman for P. A. Meyer and Son Clothier for 29 years. In 1955, Ralph opened his own business, Taggart's, a fine men's clothing store. His wife, Nancy, worked side by side with him for many years. (Carol Zimm.)

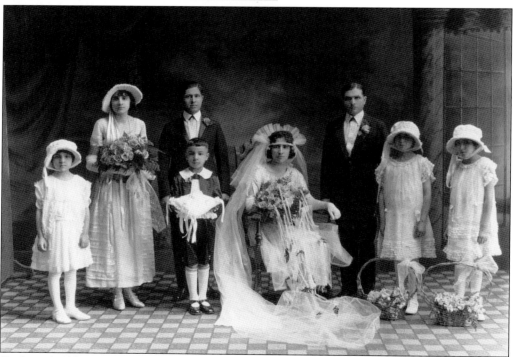

On June 4, 1924, Lena Corso married Joseph Yapello at St. Paul's Church. During their courting days, a chaperone was always present. Dating was very strict. The bride was of Sicilian heritage, and Joseph came from Calabria. Shown from left to right are Helen Sansone, Ninfa Corso, James Cutri (best man), and Phillip Sansone (ring bearer). Next to the bride is her husband and flower girls Ninfa and Lee Comella. (Antonina Siggia.)

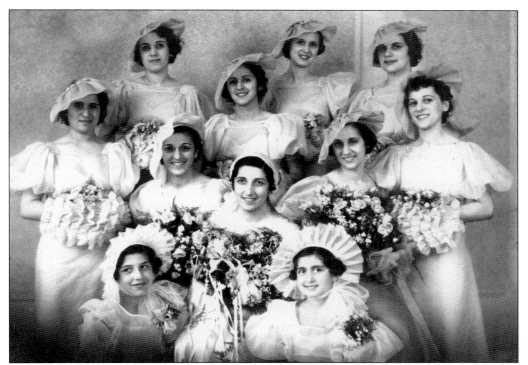

On her wedding day surrounded by her attendants is Lucy Sansone, who married Joe Ferraro in 1935 at St. Paul's Church. Left of the bride is Marion Sansone, her sister; on her right is Eleanor Yapello Agnello. Seated in the second row, from left to right, are Helen Sansone Pallotto and Maria Pistory Mercurio. Standing from left to right are cousins Nancy Cuzzola, Margaret Schiavo, Lee Comella, Ninfi Comella Culotta, Helen Adiutori Carmosino, and Frances Schiavo. (Antonina Siggia.)

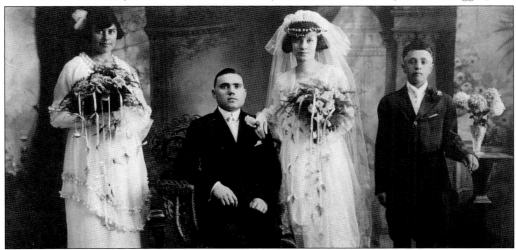

Alphonso Di Placido married Stella Sabatini Mangin in 1920. An emigrant from Pennapiedemonte, Alphonso served in the U.S. Army during World War I. He was a skilled tailor and worked for both Isaac Baker and P. A. Meyers Clothiers for many years. He and Stella had two children, Donald and Virginia. The bridesmaid, on the left, is Marietta De George, who was married to the groom's brother, Anthony. The young man on the right is not identified. (Jeanette Spinelli.)

Dolores Providenti is shown her on her wedding day in 1950. The groom is Keith Estes. Dolores's father, Michael, was born in Matrice, Italy. Her mother, Pasqualina Di Nunzio, was born in South America of Italian parents and eventually moved to Erie. The family lived at 1701 Cherry Street. Dolores was one of seven children. She graduated from Vincent High School in 1948. (Dolores Providenti Estes.)

Lucy Ferrare, daughter of Frank and Carmela Santora Ferrare, emigrants from Troia, Italy, married John Di Santi, son of Nellie and Joseph Di Santi. The marriage took place in 1937 at St. Paul's Church. John was employed at Griswold Manufacturing and Lucy worked in the Erie City Treasurer's Office. They raised two sons, John and Joseph. (Lucy Di Santi.)

In 1947, Susan Cionco traveled to Onano, Italy, to marry Ercole Masella. They had corresponded during World War II, when Ercole was an Italian prisoner of war. He was captured by the British in Africa and turned over to the Americans, who transported him to California. On a trip to California, Susan met Ercole (he was from her parents' home town, Onano, Italy). After the war, they settled in Erie. They had two children, David and Ines. (Ines Masella.)

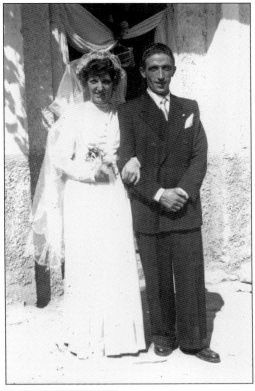

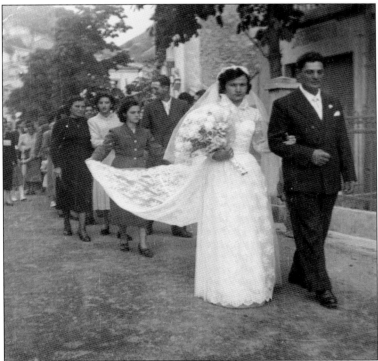

Shown here are Celestina and Giuseppe Cioccio as they walk from church in Rocca Pia, Italy. The family and wedding guests follow behind. Holding the veil is cousin Lisa Ciotti. This is the custom in many small towns in Italy. The Cioccios are part of a large group of Italians who came to Erie in the early 1950s, after World War II. (Celestine Cioccio.)

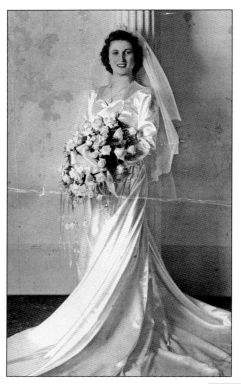

Pictured on her wedding day, April 11, 1942, is Elizabeth Ciotti. She married John "Jack" Gross, whose family owned an ice cream parlor and bowling alley called the Valledrome next to the American Theater on Eighteenth Street. Elizabeth worked at Marx Toy Factory for many years until she retired. (Joanne Werth.)

Chester Vendetti married Julia Bevilaqua in 1939 at St. Paul's Church. Chester became a successful cement and construction contractor. Julia was a school teacher. In addition, she was very active in St. Paul's Church and helped many Italian immigrants find assistance and information as they adapted to their new country. Julia's parents were Ottavio and Rosina Bevilaqua from Rio Nero Sannittico, Italy, and Chester's parents were Oreste and Maria. (Caroline Vendetti.)

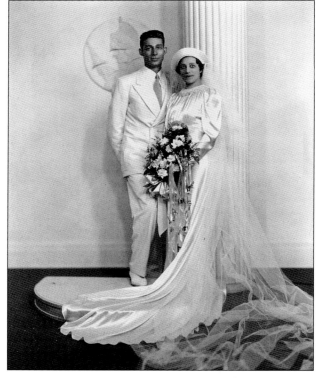

Shown here are Toby Rigazzi and Marjorie Jean Fabin leaving St. Paul's Church on their wedding day in 1956. Toby's parents were Giovana Letterio and Antonio Rigazzi. Marjorie's parents were Gertrude Zysai and Matthew Fabin. Toby had a successful career as a City of Erie policeman, retiring as a homicide detective. The couple had four children: Anthony, Diane, Kimberly, and Robert. (Joseph Adiutori.)

Pictured here is the Anthony (Giantonio) family gathered at the wedding of granddaughter Jeanne Masucci to Richard Doyle in 1947. Next to the bride is cousin Audrey Anthony Kupniewski. The bride's mother, Georgina, is on her left. The Anthonys were very prominent in Little Italy and also in the city. Grandmother Mary, third from the left, established the Altar Society at St. Paul's Church. The family roots were in Abruzzi, Italy. (Audrey Kupniewski.)

Rev. Fortunato Scarpitti, third from left, is shown at the laying of the cornerstone of the new Holy Trinity Lutheran Church on West Seventeenth Street in 1949. Reverend Scarpitti was born in Alfadena, Italy, emigrating in 1907. He graduated from Pittsburgh Theological Seminary in 1915. In Erie, he preached on street corners in Little Italy. By 1922, enough members were gathered to establish the Holy Trinity Italian Evangelical Church. He and his wife, Victoria Grigoletti, had three sons. (Holy Trinity Church Archives.)

Shown here in 1946 is the vacation Bible school at Holy Trinity Lutheran Church on West Seventeenth Street. Pastor Fortunato Scarpitti is standing at left in business suit. This mission church was established to look after the needs of Italian immigrants, blending evangelism with social ministry. Reverend Scarpitti helped many families during the Great Depression regardless of religious affiliation. (Holy Trinity Church Archives.)

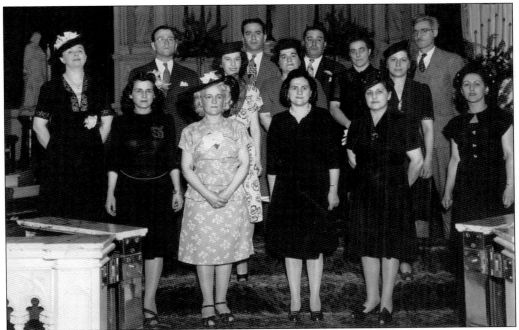

Pictured here is the senior choir of St. Paul's Church in 1947. Shown from left to right are (first row) organist Frieda Miller, Helen DiFrancisco, Josephine Di Francisco, Angeline Notarione, Ida Del Porto, and unidentified; (second row) Elizabeth Di Santis, Mary Pirrello, Julia Vendetti, and Clara Ricci; (third row) unidentified, Joseph Massello (choir director), Mr. Augustine, and Domenic DiFrancisco. Frieda Miller, the faithful organist, retired after 65 years. (Caroline Vendetti.)

A large committee was assembled for planning the 50th-year jubilee of beloved Msgr. Louis Marino's ordination. St. Paul's parishioners, pictured here in the rectory from left to right, are (seated) Rose Intrieri, Josephine Augustine, Dr. Archie De Santis, Fr. William Hastings, Ida Del Porto, Angeline Notarione, and Mary Pirrello; (standing) Chester Vendetti, Aurelio Mancini, Joseph Ruscitto, Joe De Fazio, Angelo Phillips, Nello Fiorenzo, Syl De Santis, and Louis Notarione. (Caroline Vendetti.)

A large contingent of families from northern Italy settled above East Twenty-sixth Street and Brandes Street. Their social and spiritual activities centered on the Liberty Club and Holy Rosary Church. Spaghetti dinners were a big fund-raiser. Pictured here is the planning committee for 1951. Fr. Walter Conway, pastor, is third from left. Prominent names such as Duchini, Gianoni, Verdecchia, Tullio, Butto, Serafini, Manucci, and Yezzi were part of the committee. (Jim Gianoni.)

Shown here is a gathering of officers of the Sons of Italy around 1949. While honoring Italian traditions and culture, they promoted good American citizenship and community involvement. Seated from left to right are Anna Romeo, Mrs. Carl Rossi, Gaetana Trimboli, Helen Fabrizeo, and unidentified. Standing sixth from left is Egidio Agresti, editor of *La Gazzetta*, the Italian newspaper. Frank Frattolillo is fourth from the right. The other gentlemen are not identified. (Gina Spadacene.)

Shown from left to right, Lena Soccoccio and Angeline Notarione were two of the many young women of St. Paul's Parish who devoted many hours working and planning the various functions that raised money for the church. Some of the activities were card parties, a style show, a spaghetti dinner, and dances at Rainbow Gardens at Waldemeer Park. Here they are seen in the planning session of one of these occasions. (Lena Soccoccio.)

St. Paul's Church in the heart of Little Italy had many societies that held functions to raise funds for the church's operation. Shown here are a group of young ladies modeling the latest 1950 styles at one of the many card parties held for the church's benefit. (Gina Spadacene.)

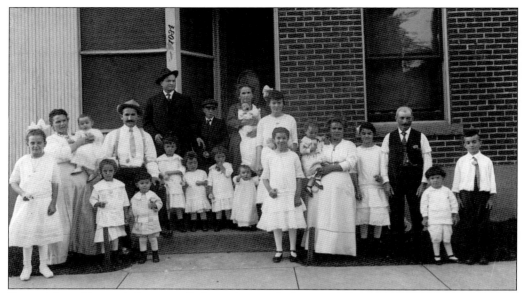

Paesani from Pennapiedemonte, Italy, gather at the home of Giovanni Mangin at 1032 West Twenty-first Street in August 1917 on the occasion of the baptism of Joseph Mangin. The baby in the background is held by his mother, Concetta DeVincentis Mangin. The family on the left is the Giovanni DeVincentis family, and on the right is the De George family. Jean Mangin Flynn is the sixth small child from the left. (Joseph Pillitteri.)

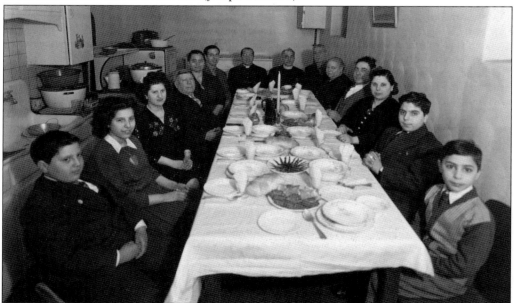

Shown on October 18, 1944, is the house blessing of Damiano and Rosalia Siggia's first home in Erie's Little Italy. After the blessing, the family had a celebration. Gathered around the table, from left to right, are Joe Licato, Mary Licato Di Georgio, Rose Licata Martini, Calorgero Licato, Rose Licato, Paul Licato, Fr. Joseph Sparacino and Monsignor Marino, both of St. Paul's Church, Giovanni Siggia, Margherita Siggia, Damiano Siggia, Rosalia Licato Siggia, John Siggia, and Charles Siggia. (Charles Siggia.)

To be nominated May Queen for the crowning of the Blessed Virgin statue was an extreme honor. A member of the Young Ladies Sodality was chosen from the group. In 1951, at St. Paul's Church, Gina Frattolillo is shown placing a crown of fresh flowers on the statue of Mary. (Gina Spadacene.)

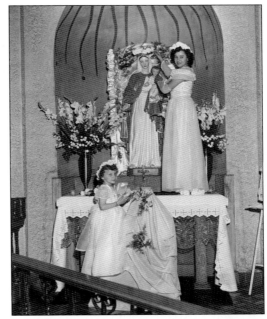

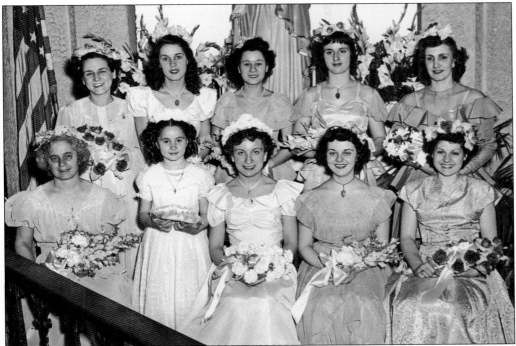

Pictured here are the May Queen and her court at St. Paul's Church in 1949. The members of the Young Ladies Sodality wore beautiful gowns as they processed down the aisle before crowning the Blessed Virgin Mary statue with a fresh flower crown. Shown from left to right are (first row) Mary Phillips, unidentified, Alberta Cifolelli (May Queen), unidentified, and Virginia Taomina; (second row) Helen Di Francisco, Rita Fachetti, Gina Frattolillo, unidentified, and Rose Leone. (Gina Spadacene.)

Domenic Di Francisco and his sister, Lucy Di Francisco, received First Holy Communion at St. Paul's Church around 1920. They were children of Rosario and Concetta Di Francisco, emigrants from Sicily. Rosario was a music teacher and taught his children how to play piano, trumpet, and violin. As an adult, Domenic, a tenor, sang in many choruses, including the Erie Philharmonic Chorus and St. Paul's and St. Peter's Cathedral choirs. (Connie Schillinger.)

Catherine Angelotti received her First Holy Communion in 1919 at St. Paul's Church. She is shown her with her godmother, Caterina Spadacene. Catherine's parents were Constantino and Rosina Angelotti, emigrants from the province of Massacarara in Tuscany, Italy. The family lived on Walnut Street in the heart of Little Italy. (Lena Soccoccio.)

The Carmelo Mobilia family lived in Little Italy then moved to North East to take up farming. Here is their daughter, Carmella Maria, on her first Holy Communion day at St. Gregory's Church in North East around 1929. Carmella graduated from North East High School, worked at General Electric, and helped on the farm. She married Charles Hake. They had four children. (Nancy Hersch.)

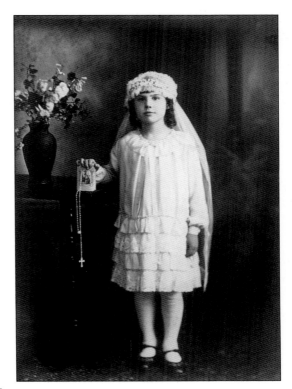

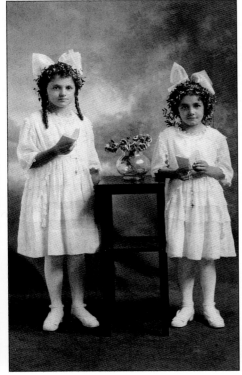

This is the First Holy Communion picture of Louise (left) and Amalia Juliante (right) taken around 1926. Their mother died when Amalia was 18 months old, and their father, Domenic, kept the family of seven children together and worked hard on the ore docks of Erie. (Elaine Fitzgerald.)

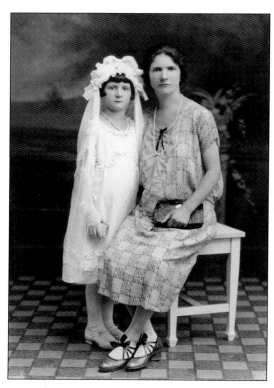

Pictured here are Giulia Di Vecchio and her daughter, Rena, at Rena's First Holy Communion in 1932. (Lee Soccoccio.)

Lillian Rufini received her First Holy Communion in 1941. Her parents, Germano and Augustina Ricci Rufini, emigrated from Montefiascone, Viterbo, Italy. Mr. Rufini served in the U.S. infantry during World War I. (Lillian Minichelli.)

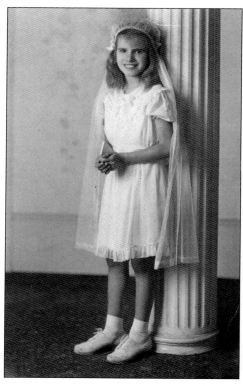

These two brothers, Robert (left) and Richard (right), are pictured on their first Holy Communion day at St. Paul's Church in 1940. Their parents were Emidio and Lucia Minichelli. Formal portraits marked many special occasions for immigrant families. (Robert Minichelli.)

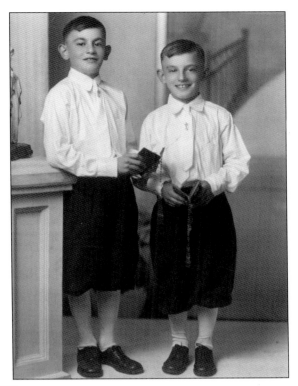

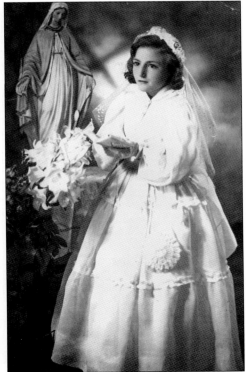

Lucy Cioccio Di Santo, age nine, is shown on her first Holy Communion day in Rocca Pia, Italy. Lucy and her family were part of a wave of Italian immigrants who came to America shortly after World War II. While visiting her aunt Maria Leone in Erie, she caught the eye of a young paesan of Rocca Pia. After some courting, Lucy and Anthony Di Santo were married. (Lucy Di Santo.)

This Christmas card photograph shows Michael and Bettie Veschecco with children, from left to right, Michael, Kristen, and Keith. Gary and Lisa were born later. The Vescheccos were active parishioners at St. Paul's Church, where both Michael and Keith were altar boys. Michael Veschecco started as a messenger in the banking business and rose to be the first Italian American to be president of a large bank, Security Peoples Trust. (Bettie Veschecco.)

Here, the Michael DePalma family gathers on the day of John DePalma's wedding at St. Paul's Church. Shown from left to right are John DePalma, Louis DePalma, Dora DePalma Ohman, Lucia and Michael DePalma (parents, who immigrated about 1916), Mario DePalma, and George DePalma. (George and Jean DePalma.)

Pictured here is Sister Mary Paul of Jesus, formerly Maryann Cutri, daughter of Jim and Maina Ferraro Cutri of 1613 Cherry Street. Maryann entered the Carmelite order after attending Mercyhurst College in the early 1950s. She made her solemn profession and veiling in May 1960 at the Carmel of St. Therese Lisieux in Loretto, Pennsylvania. Today, Sister Mary Paul, a cloistered nun, resides at the Carmelite monastery in Latrobe, Pennsylvania. (Antonina Siggia)

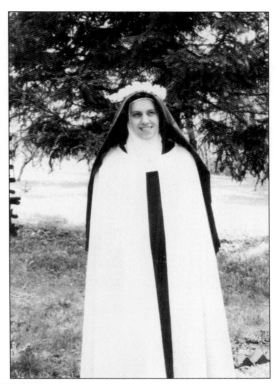

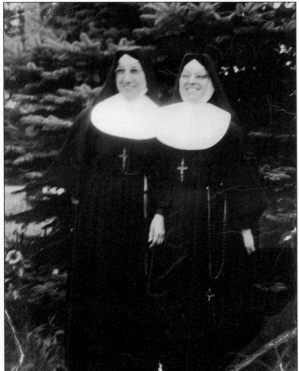

Shown from left to right are Sister Thomas Bernard (Lucy Di Nunzio) and Sister Aloyse (Theresa Massello), who entered the order of Sisters of St. Joseph from St. Paul's parish in 1928 and 1932 respectively. Sister Thomas Bernard's parents were Nick and Maria Di Nunzio, and she was one of 11 children. St. Aloyse's parents were Michael and Magdalena Fatica Massello. Sister Aloyse was one of nine children. Both sisters became school teachers in the Erie Catholic School Diocese for many years. (Anne Pirrello.)

Concetta Chiara De Francisco emigrated in the early 1900s. She and her husband, Rosario, owned a macaroni factory at 1611 Plum Street. Young son Domenic accidentally caught his fingers in the machinery and became seriously ill after surgery. Concetta prayed to St. Joseph to intercede. In thanksgiving for her son's recovery, every year on St. Joseph's Day, she prepared a bountiful feast, opening her home to everyone. The children from St. Joseph's orphanage were honored guests. A small loaf of blessed bread was given to all. To honor her memory, Concetta's descendants continue this tradition to this day. (Connie Schillinger/Julie Shadeck.)

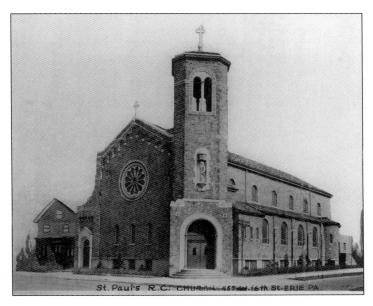

The Romanesque architecture of St. Paul's Church stands as a monument to the faith and devotion of the Italian community throughout its history. Evolving from a humble wooden sanctuary this magnificent church, was dedicated in 1935. Though Little Italy has changed over the years, Italian Americans remember their roots and continue to attend and support St. Paul's Church and the many social and religious events that take place there. (St. Paul's Archives.)

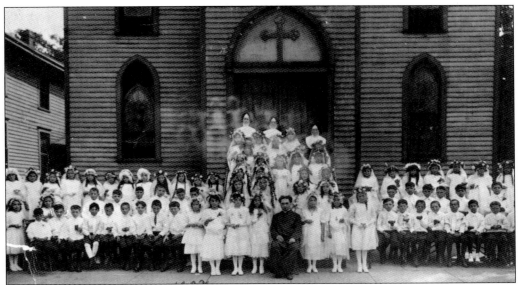

This First Holy Communion class picture, taken in 1922, reflects the many children who were coming of age, attending school, and beginning to be part of the American experience. Father Marino is seated among the children in the first row. The Sisters of St. Joseph are in the back row. Catechism classes were taught on Sunday morning after mass. (St. Paul's Archives.)

www.arcadiapublishing.com

Discover books about the town where you grew up, the cities where your friends and families live, the town where your parents met, or even that retirement spot you've been dreaming about. Our Web site provides history lovers with exclusive deals, advanced notification about new titles, e-mail alerts of author events, and much more.

Arcadia Publishing, the leading local history publisher in the United States, is committed to making history accessible and meaningful through publishing books that celebrate and preserve the heritage of America's people and places. Consistent with our mission to preserve history on a local level, this book was printed in South Carolina on American-made paper and manufactured entirely in the United States.

This book carries the accredited Forest Stewardship Council (FSC) label and is printed on 100 percent FSC-certified paper. Products carrying the FSC label are independently certified to assure consumers that they come from forests that are managed to meet the social, economic, and ecological needs of present and future generations.

FSC
Mixed Sources
Product group from well-managed forests and other controlled sources

Cert no. SW-COC-001530
www.fsc.org
© 1996 Forest Stewardship Council

Find Your Place in History.